奇跡の動物家族
命をつなぐ
One Big Happy Family

ライザ・ロガック
宮垣明子 訳

K&B
PUBLISHERS

One Big Happy Family
HEARTWARMING Stories of Animals Caring for One Another
by Lisa Rogak
Copyright © 2013 by Lisa Rogak. All right reserved.
Japanese translation rights arrangement
with the Mendel Media Group LLC of New York
through Japan UNI Agency, Inc.

アレックスへ
わたしたちふたりも
ちょっと変わった組み合わせね……

目次

はじめに ……………… 12

おかあさんになった犬

ちょっとその哺乳びん貸して！ ……………… 20
スプリンガー・スパニエルとヒツジ

え？ あたしまたこんなに子どもを産んじゃったの？ ……………… 23
ブルドッグとリス

母性本能の正体なんて、詮索しないでくれる？ ……………… 26
ゴールデン・レトリバーとウサギ

ここにもひとつのクールジャパンがありました ……………… 30
秋田犬とライオン

いろんな子ども育てたけど、この子は特別なのよ ……………… 33
ミックス犬とリャマ

動物の面倒は動物にまかせておくのがいちばん ……………… 36
ジャーマン・シェパードとベンガルトラ

母親がイヌなら離乳食もドッグフード ……………… 39
ポインターとピューマ

5

災害ボランティアのつもりだったんだけど
ジャーマン・シェパードとネコ ………… 42

猟犬のあたしが獲物の母親にされちまった
フォックスハウンドとキツネ ………… 45

あたし、赤ん坊に弱いのよ
グレイハウンドとシカ、キツネ、ウサギ ………… 48

だって、体の柄がそっくりだったんだもん
ダルメシアンとヒツジ ………… 52

ご注意！しがみつくクセは治りません
ミックス犬とショウガラゴ ………… 55

最後は命がけの子育てだったよ
ボーダーコリーとミニブタ ………… 58

世界を救うのはきっと、母性なんですね
ラブラドールとコビトカバ、トラ、ヤマアラシ ………… 61

この子が大好き！
あたしを捨てた実の母よりどれだけいいか
グレートデンとシカ ………… 66

同情のつもりが愛情に変わったということかもね……
ボクサー犬とブタ

そうか、ぼくの前世は犬だったかも
ミックス犬とアナグマ

いやあ、子育てというのは大変なんですよ……
チワワとマーモセット

父性はそのまま母性にもなるってことさ……
ボーダーコリーとハイエナ、トラ

命にかかわるときは、ペットも野生もないって……
ミックス犬とカンガルー

三つ子だからって見殺しにはできないよ……
ボクサー犬とヤギ

愛してるからさ、離れたくないんだよ……
ジャーマン・ショートヘアード・ポインターとコノハズク

大きな犬と小さなモルモットの愛情物語……
エアデール・テリアとモルモット

残念ながら「いじめ」は動物の世界でもあるんだよ……
イヌとサル

おれの趣味は子育てだけど、こんどはアヒルかい？……
イエロー・ラブラドールとアヒル

70
73
76
78
82
86
88
91
94
96

犬猿の仲なんてウソ。とても犬身的なんです………………
グレートデンとチンパンジー

なぜひよこだって？ おれにだってわからんよ …………… 102
ケルピー犬とひよこ

猫たちの新しい家族

種類が違うとはいえ、別れはお互いつらいもの ……………… 106
ネコとライオン

だって、アタシはネコなんでしょ？ ……………… 109
キツネとネコ

ふんわりふさふさの感触もネコっぽかったのかな ……………… 112
ウサギとネコ

やっぱり似た者どうしの心地よさってあるんだね ……………… 116
ネコとひよこ

魔法のシャネル5番 ……………… 118
ネコとリス

自分の子どもを亡くしたらネコだって淋しいのよ ……………… 122
ネコとカモ

99

みんなひとつの家族

豚のお乳を飲むと豚になってしまうというハナシ？……… 125
ブタとネコ

母親に捨てられたイヌたちがネコの家族になった……… 128
さび猫とロットワイラー

あまりにカワイイから、つい仏心、ってやつよ……… 134
ライオンとレイヨウ

子犬といるとあたし、目が優しくなるんです！……… 137
チンパンジーとイヌ

トラだってライオンだって、育てるのは俺さ……… 140
オランウータンとライオン

親のいない寂しさはあたしがいちばん知ってるもん……… 144
ヒヒとショウガラゴ

猛獣オオカミとしてはちょっと照れるぜ……… 146
ヤギとオオカミ

イクメンのハシリはサルでした！……… 148
タマリンモンキーと双子のマーモセット

子牛に見間違えたわけじゃないんだけどね……152
ウシとヒツジ

動物保護と食肉の微妙な問題で有名になったよ……154
ブタとヒツジ

鳥たちのニューファミリー

いのちのちがいのちを継いでいく、という話ですよ……158
メンドリとロットワイラー

ニワトリがアヒルを産んだ!?……161
メンドリとハヤブサ

種の絶滅を救ったチャボのお手柄……164
チャボとアヒル

うちの子は大食いでね……167
ヨシキリとカッコウ

子どもを産めない猛禽がイラついた!……170
フクロウとアヒル

あたしの子じゃないからって、どうなのよ?……172
クジャクとガチョウ

10

気にしない気にしない、みんな鳥なんだもの
ニワトリとアヒル、カモ …………… 174

注………………………… 178
写真引用元 …………… 183
ありがとう——♥ ……… 186

はじめに

アメリカのカリフォルニア州にあるゴリラ財団という動物保護施設には、手話で人間と会話できるメスのゴリラ、ココがいます。

ココは約1000語のアメリカ手話を使いこなします。それに加え、英語の話し言葉も2000語以上を理解しているのです。ココはいつも、「ネコ」と手話でこたえていました。

1984、その願いがとうとうかないました。

1匹の子ネコが、ココにペットとして与えられたのです。

ココはオール・ボールと名づけたその子ネコを、いつも大切そうに抱きしめていました。まるで自分の子どもをかわいがるようなココの姿に、飼育員はみな驚きました。残念なことに、オール・ボールはのちに車にひかれて死んでしまいました。そのことを伝えられたココは「悪い、悲しい、悪い」「しかめつら、泣く、しかめつら、悲しい」と手話を使って感情を表したといいます。

ココと子ネコの例は、その氷山の一角にすぎません。新聞やオンラインニュースで動物どうしの心あたたまるエピソードは、世の中に数えきれないほどあります。

も毎週のようにそんな動物の話題が取り上げられていますから、みなさんもよくご存じでしょう。

動物たちの絆を見ていると、子どもをいつくしみ育てることは、ときには種の違いさえ関係なくなるほど強い本能だとわかります。

「動物が種の違う子どもを育てるのは、珍しいことではありません」と言うのは、イヌに関する著書も多いマーサー大学動物行動心理学教授、ジョン・C・ライト博士です。「ほかの動物を世話するのはホルモンの影響です。そればかりでなく、年齢的に育児に適していたということもあるでしょう。若い個体のほうが順応性があり、どんな相手でも受け入れることができるからです。人間と同じように、動物もいっしょに生きる仲間を求めているのです」*

動物のなかでも、鳥類は特に子育ての本能が強いといいます。親鳥がひなの成長から巣立ちまで見届けるのと同様、ひなも自分の力で親を見つけようとします。種の違うトリや、身近にいるネコやイヌが親代わりになるだろうということは誰でも想像がつくでしょうが、ローレンツの研究ではガチョウやシチメンチョウ、カモなどにみられる、すりこみと呼ばれる行動は、オーストリアの博物学者コンラート・ローレンツの研究で20世紀初めに発表されました。ローレンツによれば、そうした鳥たちはふ化して数時間から数日のうちに目にした、大きな動くものを親と思いこみます。

「トリは、足もとに卵を置かれれば本能的にあたためます」と言うのは、イギリス鳥類ブーツやボールのほか、おもちゃの電車にまでついて歩いたことが挙げられています。

学研究会のグラハム・アップルトンです。

「生まれたひなも最初に目に入ったものを母親とみなし、すぐに食べ物をくれと必死で鳴き声をあげます。親ならえさをくれるのが当然というわけです」

アップルトン氏はクジャクがガチョウのひなの親代わりを務めた例を挙げました。

「ガチョウのひなは親の行動をすべて真似するという本能があるのですが、そのひなは困っていましたね。泳げないクジャクの真似をしていても、泳げるようにはならないですから」*

動物学者や、野生動物保護区域の動物リハビリセンターで働くスタッフらは、種の異なる親子をたくさん目にしています。野生よりも保護された環境のほうが、そういった関係は起こりやすいようです。

絶滅危惧種の保存と研究のために、世界中で多くの霊長類が保護されていますが、なかでもオランウータンは野生での生活環境が個体によってさまざまで、子育ての方法も能力もまったく違うといいます。

「人間がどれほど努力してオランウータンに最適な設備を整えたとしても、野生における生活環境とまったく同じというわけにはいきません」と、イギリスのレスターシャーにあるトワイクロス動物園の創始者、モリー・バダムは著書のなかで語っています。

「オランウータンのオスは、野生では1頭で生活し、交尾するときだけメスたちのもとへ行きます。メスは子どもを産むと、ほかの母親たちと子育てグループのような群れを形成し、いっしょに行動します」**

野生のオランウータンはこのように、母親になると群れの経験豊富なメスから子育てを教わるのです。しかし動物園では、より多くの子どもが生まれるよう、オスとメスのペアだけで生活させています。

野生とは異なる環境で飼育されているわけですから、飼育員は母親を注意ぶかく見守り、頃合いをみて子育てのしかたを教えてやらなくてはなりません。

幸い、子守りや教師、またはベビーシッターの役目を引き受けようと待ち構えている動物が、動物園のなかにはたくさんいます。

トワイクロス動物園の場合、育児放棄されたサルなどの子どもの親代わりとなって育てたのは、イヌ好きのモリー・バダムが飼っていたグレートデンでした。「グレートデンのなかで、サルの子どもが近くに寄ってきても嫌がらず、じっと辛抱しているような子を選んで、親代わりにしました。グレートデンたちが助けの必要な動物の子どもたちとうまくやっていくことができたのは、捨てイヌだったところを保護された子たちばかりだったからかもしれません」*

この本では、ガチョウの卵を世話したクジャクや、子ネコに乳を与えて育てたブタなど、驚くような組み合わせの親子がたくさん紹介されています。

とはいっても、大半はイヌが親代わりとなった例です。

イヌはごく一般的なペットなので、違う動物を育てる機会も多いのだろうと思われるかもしれません。

けれどイヌが犬種に適した仕事をし、人間の手助けをするベストフレンドと呼ばれ

るまでになったのは、人間がそうなるように訓練し、交配してきたからです。

「イヌは人間によって、動物らしからぬほどひとなつこく、我慢づよい気質につくりかえられました」と、ブリティッシュ・コロンビア大学心理学教授のスタンレー・コレン博士は言います。

「イヌは全般的に、ネオトニー（幼形成熟）と呼ばれる状態にされています。死ぬまでずっと子イヌのままのような姿につくりあげたのは人間なのです」*

初期のイヌは、目は細く耳はとがって上を向いた、オオカミに似た姿でした。それが垂れた耳に大きな目の、子イヌのような愛らしい体型にされてもなお、ほかの動物の親になりたがるというのは興味ぶかいとコレン博士は言います。

また、ネオトニーの度合いが少ないイヌがほかの動物の親代わりをしたがる場合、その対象は生まれたばかりの赤ちゃんであることがほとんどです。哺乳類の子どもが持つ、ある種のフェロモンが『赤ん坊らしいにおい』を発することがその理由でしょう。本来は動物が子どもを守ろうとする本能を刺激したり、ほかの大人に警戒心を持たなくさせるためのフェロモンなのですが、それが哺乳類どうしで似通っているため、種類の異なる動物でも反応してしまうようです」**

この本で紹介されている親子関係には、どちらかが死ぬまで続くものもあれば、ごく短期間のものもあります。

動物の寿命は人間より短いものがほとんどなので、子どもでいる期間も数か月から、わずか数週間しかないものもいます。幼い生き物を死の淵から救い、育てあげるとい

16

う行動を動物がごくあたりまえに行うのは、子どもが大人になるまでにそれほど時間がかからないからかもしれません。

また、この本で紹介されているさまざまな例のなかには、肉食動物と草食動物の親子もいます。

野生なら死に至るほどの傷を負わせる相手を優しく育てる肉食動物たちは、肉食としての本能よりも、父として母としての本能に体の内側から突き動かされ、一個の親として子どもを育てているのです。

動物は、本当に親を必要としている子どもを大切に育てます。

わたしたち人間も、そこから親のありかたを学ぶべきだと思えてなりません。

おかあさんになった犬

ちょっとその哺乳びん貸して！

スプリンガー・スパニエルとヒツジ

牧場ではあちこちに散らばるヒツジをまとめるためにイヌが飼われています。

イヌはヒツジの群れをまとめたりオオカミなどの外敵から守ったりするほか、忙しい一日が終わって疲れ果てた人間を癒す役割もあります。

イギリスのデヴォン州で毎日180エーカーの牧場を駆けまわるメスのスプリンガー・スパニエル、ジェスは、そういった普通のイヌの仕事ばかりでなく、子ヒツジにミルクを飲ませるのもお手のものです。

10才のジェスはまだ自分が子どものころから、親のいない子ヒツジを同時に何頭も世話してきました。子ヒツジたちのもとに哺乳びんをくわえて運び、そのまま飲み終わるまで支えていてやるのが日課です。

「もともとはわたしが子ヒツジにミルクをやるときに哺乳びんを運んでくるよう教えたんですが、いつのまにかジェスが自分でくわえて飲ませるようになりました」*と、牧場主のルイーズ・ムーアハウスは言います。

「それ以来、ジェスはずっとヒツジの親代わりをしています」

お腹を空かせた子はいないかと哺乳びんをくわえて走りまわるジェスの姿を見ると、自然と笑みがこぼれてしまうと、ムーアハウスは言います。

ジェスはそのほかにも、水やえさの入ったバケツを運んだり、言いつけられた道具

20

スプリンガー・スパニエルは毎年毛が生え替わるので、ほかの犬種より頻繁にグルーミングが必要です。

◆ちょっとその哺乳びん貸して！

を取ってくるなど、ムーアハウスの指示を受けていろいろな仕事をこなしています。牧場では２７０頭もの珍しい種類のヒツジを飼育しているので、ジェスがいなかったら牧場はやっていけない、とムーアハウスはすっかり頼りにしています。
「ジェスは人間がもうひとりいるのと同じくらい仕事をしてくれますからね」
人間にとってもヒツジにとってもかけがえのない存在のジェスですが、最近ではまたひとつ仕事が増えたといいます。
それは、新人の教育係。ジェスは新入りのコッカー・スパニエル、リリーに、ヒツジの集め方だけでなく、子ヒツジの世話のしかたも教えているそうです。

え？ あたしまたこんなに子どもを産んじゃったの？

ブルドッグとリス

イギリスのワーウィックシャーに大きな嵐が吹き荒れた翌朝、レスリー・クリューズは自慢の花壇が荒れてはいないかと心配で、目を覚ますとすぐ庭に出ました。

幸い、花壇も菜園も無事だとわかりほっとしたクリューズは、家に戻ろうとして、何かが芝生の上で丸まっているのに気づきました。

それは嵐のなかで巣から落ち、そのまま母親に見捨てられてしまった、3匹の子リスでした。

クリューズは急いで子リスたちを拾いあげて家に入り、スポイトを探し出すと、1滴ずつミルクを入れ、飲ませてやりました。そしてひとまず家にあるもので作った寝床に子リスたちを入れ、仕事に出かけました。

自分が父親代わりになって子リスたちを育てられないだろうか、とクリューズは動物好きの同僚に相談しましたが、リスのような小動物の子どもは人間が育てても遅かれ早かれ死んでしまうよ、と言われてしまいます。

がっかりして帰宅したクリューズを玄関に出迎えたのは、ブルドッグのスージーでした。

スージーは子育て中でしたが、子イヌたちはもう大きくなってスージーにまとわりつくこともなくなっていました。子イヌたちはあと数日のうちにもらわれてい

▶ え？ あたしまたこんなに子どもを産んじゃったの？

おかあさんになった犬

え？ あたしまたこんなに子どもを産んじゃったの？

ブルドッグは品種改良を重ねるうちに頭が大きくなりすぎたため、いまでは出産の80パーセントが帝王切開だといいます。

え？　あたしまたこんなに子どもを産んじゃったの？

からスージーの手が空く、と思い出したクリューズに、名案が浮かびます。クリューズはイヌはリスを追いかけ回すものだということは重々承知のうえで、子リスの世話をスージーに任せてみることにしました。

そこで寝床にいるスージーのお腹の上にそっと子リスたちを並べてみました。しばらく見守っていると、子リスたちはスージーのお乳を飲みはじめました。スージーも、いつのまにかまた子どもが生まれたとでも思ったのか、穏やかな目で子リスたちを見つめていました。

ついこのあいだまで子イヌたちがいた場所にするりと入りこんだ子リスたちは、まるでこのとき生まれたときからスージーのそばにいたような、安心しきった寝顔をしていました。

それからしばらくたって、面白い組み合わせの親子がいるといううわさを聞きつけた写真家のジョン・ドライスデールが、ほほえましい姿を撮影しにやってきました。まずは子リスたちの写真を撮ろうとカメラをセットしたところで、それに気づいたスージーが「子どもたち」を守ろうとその前に立ちふさがって、いっこうに撮影許可をくれなかったので、ドライスデールはすっかり困りはててしまったのでした。

おかあさんになった犬

母性本能の正体なんて、詮索しないでくれる？

ゴールデン・レトリバーとウサギ

2011年の春、サンフランシスコに住むティナ・ケースは、イヌを飼いたいという3人の娘たちの願いをとうとう聞きいれることにしましたが、条件をふたつ出しました。ひとつは、自分たちできちんと世話をすること。もうひとつは、自分たちでお金を貯めて買うこと。

それを聞いた娘たちは、近所の家を片っぱしからまわって、ペットの世話やベビーシッターのアルバイトに励みました。

3人でそうやってせっせと貯めたお金で買ったのが、メスのゴールデン・レトリバー、コアです。

コアはすぐに家族になつき、まるで末の妹のようにみんなに甘えていました。ただひとつ悪いくせは、裏庭でトカゲを追いかけて遊ぶことでした。いかにもイヌらしい遊びでしたし、トカゲを家のなかまで持ちこんできたりはしなかったので、家族も大目に見ていました。

ある日、いつものとおりトカゲを追い回していたコアが、なぜか庭の土が盛りあがったところにばかり何度も顔を突っ込んでいました。何かいるのかと娘たちがこわごわのぞきこんでみると、そこにあったのはなんとウサギの巣でした。なかには親のいない赤ちゃんウサギたちが身を寄せあっていたのです。

母ウサギが子ウサギの世話をするのは、一日わずか5分程度です。

母性本能の正体なんて、詮索しないでくれる?

母性本能の正体なんて、詮索しないでくれる?

娘たちは急いで赤ちゃんウサギを近所に住む獣医のところへ連れていきました。そこで健康に問題なしとのお墨つきをもらい、飼い方も教えてもらいました。

ティナと3人の娘たちはウサギの赤ちゃんを飼うつもりでいました。でもコアは自分が見つけたのだから当然といった様子で、帰ってきた子ウサギたちを抱えるように、そのわきにどっしりと寝そべったのです。

イヌはウサギを追いかけ回すものと思っていた娘たちはあっけにとられました。

それでも、ウサギたちをわが子と思っているコアの決心は固いようでした。ティナはコアの母性本能に任せることにしました。

「コア自身は子どもを産んだことがないけれど、ウサギたちをわが子と思っているようですね」と、ティナは言います。

「ウサギたちはコアの体の上をぴょんぴょん跳ねまわったり、脚のあいだにもぐりこんで温まったりしています。コアがそばにいると安心しきっていますよ」*

ここにもひとつのクールジャパンがありました

秋田犬とライオン

1998年、スコットランドのグラスゴーにある動物園では、ある試みに取り組むことになりました。

60年の動物園の歴史のなかで初めて生まれたインドライオンの赤ちゃんの母親代わりを、イヌに任せてみようというのです。

動物園では、親が育児放棄したトラやライオンの子どもたちをすべて人工飼育していました。ですが、たくさんの子どもに何週間ものあいだ、2時間おきにミルクを与える作業は飼育員の仕事に支障をきたしていました。

アフリカにある野生動物保護施設では、イヌとライオンの組み合わせでの飼育がごくあたりまえに行われていると知った飼育員たちは、自分たちの動物園でもその方法を試してみようと考えました。

うまくいくのか、あるいは危険な賭けなのかは誰にもわかりませんでしたが、飼育員たちは人工飼育以外の新たな方法を見つけたい気持ちでいっぱいだったのです。

母親代わりには、人間に強い忠誠心を持ち、自立心の強いことで知られる秋田犬がよいということになりました。

そこで選ばれたのが、メスの秋田犬、コネコです。

コネコとライオンの赤ちゃん、サムは、出会った瞬間から親子そのものでした。ま

1920年代中ごろの東京で、亡くなった主人の帰りを待ち続けたハチ公という秋田犬の話は有名です。ハチ公は1935年に亡くなるまで毎日、帰るはずのない主人を駅に出迎えに来ていたそうです。

おかあさんになった犬

■ ここにもひとつのクールジャパンがありました

るで神様が引き合わせたかのようだと、誰もが思いました。
仲良く暮らしていたふたりは、それから1年後、イギリス中部にあるダドリー動物園に移されるときもいっしょでした。
けれども、ふたりの生活は、サムの成長とともに終わりをむかえます。
大人になったサムは海を渡ったスウェーデンの動物園で、同い年のメスライオンと結婚しました。
ひとりになったコネコは、イギリスの一般家庭にもらわれていきました。

いろんな子どもを育てたけど、この子は特別なのよ

ミックス犬とリャマ

イギリスのエセックスのとある牧場では、家畜以外にもいろいろな動物を飼育しています。そのなかのリャマの子どもが、今回の主人公です。

マホガニーと名づけられたその子どもは、母親にとって初めての出産でした。リャマは群れで暮らす動物なので、若い母親はほかのリャマの子育てを見て学びます。

ところが出産したその母親リャマは野生から保護されたばかりでまだその経験がなく、自分が子どもを産んだことにショックを受けて育児を放棄してしまいました。独りぼっちになってしまった動物の子どもは誰かが代わりに育てなければなりませんが、そのころ牧場は忙しい時期で人手が足りず、マホガニーをみてやる余裕がありませんでした。

そこで牧場主は、ちょうど子イヌの離乳を済ませたばかりのミックス犬、ロージーに任せようと考えました。

ポインターとローデシアン・リッジバックの雑種であるロージーは体が大きく、以前にもライオンやトラの子どもの面倒をみた経験があったからです。ほかの動物の子どもを扱うコツのようなものを知っているのか、ロージーはいつも楽々と子育てをしているようでした。

▎いろんな子どもを育てたけど、この子は特別なのよ

33　おかあさんになった犬

いろんな子どもを育てたけど、この子は特別なのよ

リャマの子どもを指して、クリアという呼び方をすることもあります。クリアは生後3か月までは、毎日1ポンドずつ体重が増えます。

いろんな子ども を育てたけど、この子は特別なのよ

マホガニーの姿を見たロージーは、喜んで母親代わりを引き受けました。自分の子どもだけでなくほかの動物の子どもも数多く育ててきたロージーでしたが、リャマのマホガニーはそのなかでも特別だったようです。そばにいるだけでうれしい、とお互いに感じていることははた目にもわかりました。マホガニーが大人になり、母親代わりとして世話をしてやることなどなくなってからも、ロージーはそっとそばにつきそっていました。
そこで牧場主の一家は自宅のキッチンの一角にふたりの寝床を作ってやり、仲良しの親子をあたたかく見守りました。
家族の日課である夕暮れの散歩の時間になると、イヌと連れだってリャマも出てくるようになりました。

動物の面倒は動物にまかせておくのがいちばん

ジャーマン・シェパードとベンガルトラ

2001年の春、オーストラリアのシドニーにほど近い町を豪雨が襲いました。被害に遭ったのは人間ばかりではありません。住むところも食べるものもなくしたのは、野生動物も同じでした。

生まれたばかりの子どもを抱えた動物や、親を亡くしたまだ若い動物も、みな生きるために必死でした。

豪雨で命を落とした動物もたくさんいるなかで、人間に保護された4匹のベンガルトラの兄弟は大変な幸運を手に入れました。たどりついた先が、テレビ司会者としても有名な獣医、ロブ・ザミット博士のもとだったのです。

当時、ベンガルトラは絶滅の危機に瀕していました。いまでこそ、ナショナル・ジオグラフィック協会の試算による個体数は2500頭にまで回復していますが、そのころは1000頭を切っているといわれていました。

獣医のザミット博士は、ベンガルトラの子どもをなんとしても助けなければならない、と使命感に燃えていました。

トラの子どもたちを助けようと意気ごんだのは、なにも人間ばかりではありません。ザミット博士が飼っているメスのジャーマン・シェパード、ペッパーも積極的にトラの子どもたちの世話に参加したのです。

> トラの子どもは、母親のもとで3年近く暮らします。

動物の面倒は動物にまかせておくのがいちばん

おかあさんになった犬

◆ 動物の面倒は動物にまかせておくのがいちばん

「わたしたちがトラの子どもたちを育てると決めたとき、ペッパーも母親代わりに名乗りを上げてくれたのは心強かったですよ、四頭もの子どもを育てるのは大変な仕事ですから」*と、ザミット博士は言います。

お乳を飲ませることはできませんでしたが、それ以外の世話は、ほとんどペッパーがしていました。

「ペッパーはトラの母親がやることはほとんどしています。体を舐めてきれいにしたり、トイレトレーニングもしていますよ。子どもたちが楽しそうに遊んでいれば、そばでじっと見守っています」**

ザミット博士によると、日が暮れてからのペッパーとトラの子どもたちのお楽しみは、テレビの前に陣取ってのんびり映画を見ることだそうです。

お気に入り? もちろん『タイガームービー』と『ライオン・キング』ですよ。

母親がイヌなら離乳食もドッグフード

ポインターとピューマ

イギリスのダベントリーでレイ・グラハム・ジョーンズが開いている動物園には檻がなく、放し飼いの形式になっています。

あるとき、母親とはぐれた1頭のピューマの赤ちゃんが、翌朝になっても鳴きながらふらふらとさまよっていました。

赤ちゃんはすぐ母親のもとに戻されましたが、母親は赤ちゃんが近くに寄ることすら拒否しました。おそらく離れていたあいだに、赤ちゃんの体に何か違うもののにおいがついたため、警戒したのでしょう。

まだ幼いピューマは数時間おきにお乳を飲まないと死んでしまいます。夜中のうちに母親とはぐれてしまったであろうその赤ちゃんは、長時間栄養をとっておらず、命が危ぶまれました。

そこで飼育員が人工乳を作って与えましたが、ピューマの赤ちゃんは飲もうとしません。

ジョーンズは、近所に住むイヌのブリーダーに乳の出るイヌはいないかと相談しました。

運の良いことに、ジュディというポインターが最近子どもを産んだばかりだということだったので、飼育員はピューマの赤ちゃんを抱えてジュディのもとへ走りま

ピューマにはいろいろな別名があります。アメリカライオン、クーガー、パンサー、オオヤマネコと呼ばれるものも、すべてピューマのことです。

▼ 母親がイヌなら離乳食もドッグフード

母親がイヌなら離乳食もドッグフード

した。

ロッピーと名づけられた赤ちゃんは、子イヌと並んで無我夢中でジュディのお乳を飲み始めました。その姿を、ジュディは優しく見守っていました。

そのまま、ロッピーはジュディに預けられることになりました。

ロッピー自身は、母親代わりがイヌだということに気づいた様子もなく、乳兄弟の子イヌたちとじゃれあったり、甘えてジュディにまとわりついたりしながら、すくすくと成長しました。

数週間後、すっかり大きくなったロッピーを見て安心したジョーンズは、ロッピーを離乳させるため、ドッグフードを与えることにしました。

ジュディの乳を飲まなくなれば、ロッピーは動物園に戻され、大人のピューマ同様、肉を食べるようになるでしょう。

けれどロッピーがそこまで成長したのは、乳を与えるだけでなく、自分の子ども同様にいつくしんで育てた、ジュディのおかげなのです。

災害ボランティアのつもりだったんだけど

ジャーマン・シェパードとネコ

2009年2月、オーストラリア南西部のビクトリア州を大規模な山火事が襲いました。

レスキュー隊によって助け出された野生動物の子どもたちは、つぎつぎと周辺の動物病院に保護されました。

町の獣医、トレイシー・ジェイミソンのもとにも、生後3週間の子ネコの兄弟が3匹運びこまれます。

こころよく受け入れたものの、子ネコたちの汚れを順に拭いてやり、けがの手当てをし、ミルクを与え、そそうを片づけているあいだにも、子ネコたちが不安のあまり鳴き始めるというめまぐるしさに、ジェイミソンはすっかりまいってしまいました。

すると、飼っていた4才のジャーマン・シェパード、ルカが、子ネコたちの世話をかってでたのです。

ルカは、エマ、ベン、ルイーズと名づけられた子ネコたちがすり寄ってきても嫌な顔ひとつせず、体を舐めて毛づくろいをし、寄りそって眠らせてやりました。自分は子どもを産んだこともないのに、まるでずっと前からそうしていたかのような落ちつきをみせ、子ネコたちの母親代わりとなったのです。

その翌週、新たに3匹の子ネコが運びこまれたので、ジェイミソンはまたルカに

ジャーマン・シェパードの毛は二層になっています。外側の毛はある程度長さがあって硬く、定期的に抜けますが、内側の毛は羽毛のように柔らかくて短く、めったに抜けません。

おかあさんになった犬

■ 災害ボランティアのつもりだったんだけど

預けてみることにしました。

新たにやってきた生後2週間のハンナ、アメリア、ザックは、ジャーマン・シェパードの毛皮にくるまって眠る先輩3兄弟の隣になんの迷いもなくもぐりこみました。ルカは突然6匹もの子ネコの母親代わりとなりましたが、その役目にすっかり満足しているようでした。

「どの子もすっかり元気になったので、もらい手をさがさなくてはならないのです。でもきっとルカが寂しがると思うと気がすすまなくて」* とジェイミソンは言いました。

猟犬のあたしが獲物の母親にされちまった……

フォックスハウンドとキツネ

子どもを育てようという動物を、誰も止めることはできません。違う動物の子どもでも、育てたいと思えば育ててしまうのです。それが自分の産んだ子どもでも、ママという名前のフォックスハウンドが、まさにそうでした。

2011年9月、アメリカのコネチカット州にあるLEO動物自然環境保護センターでは、園長のマルセラ・レオーネが頭を悩ませていました。

フェネックギツネのフィオナの妊娠が確認されたのですが、フィオナはそれまで何度も育児放棄したり、ひどいときには生まれてすぐに子どもを喰い殺したりしていたのです。今回もおそらく、フィオナは育児をしないでしょう。

そこでレオーネ園長は、フィオナが子どもを産む時期にちょうど離乳させる母イヌを見つけ、子ギツネの親代わりにすることを思いつきました。体の大きさもフェネックギツネに近いチワワぐらいの小型犬が適していると園長は考えていました。

フィオナの出産が近づいたある日、レオーネ園長はアダプト・ア・ドッグという里親仲介団体に、離乳の近いイヌがいないか打診すると、ノースカロライナ州の保護シェルターにママという名前の母イヌがいることがわかりました。

ママは親を亡くして路上をうろついていた6匹の子イヌを助けようと車の前に飛び出してきたので、子イヌたちとまとめて保護されたというのです。育児本能の強さ

▲ 猟犬のあたしが獲物の母親にされちまった……

45 おかあさんになった犬

キツネの出産シーズンは12月から2月。大人になったキツネは巣で眠ることはありませんが、子ギツネを世話しているこの時期の母ギツネだけは例外です。

はレオーネ園長の求める条件にぴったりでした。

ところがアダプト・ア・ドッグから渡された写真を見てびっくり。ママは小型犬でないどころか、なんとキツネ猟に使われるフォックスハウンドだったのです。

それでも、レオーネ園長は自分の身を危険にさらしても子イヌを救おうとしたママの育児本能の強さを信じ、引き取ることに決めました。

そこでママと6匹の子イヌたちはノースカロライナからコネチカットまで連れてこられました。子イヌたちは里親に引き渡され、ママはLEOに向かいました。

ママが保護センターの門をくぐったのと、フェネックギツネの子どもたちが生まれたのがほぼ同時でした。ママは到着してすぐにキツネ舎に入れられました。

ところが、子ギツネたちを見るとママはうなり声を上げて飛びかかろうとしました。職員たちは時間をかけることにしました。子ギツネたちは保育器で育て、2時間ごとの授乳のときだけママをそばに連れてくることになりました。

授乳の際は、まず職員のひとりが横になったママの頭そらしを、もうひとりがママの体をおさえ、さらにもうひとりが子ギツネたちに乳首をくわえさせました。

人間3人がつきっきりになった初めての授乳には1時間かかりましたが、じきになごやかに進むようになり、人間が立ち合わなくてもよくなりました。

ママは猟犬の本能をおさえ、子どもたちを一生懸命育てるようになったのです。

「ママは子ギツネたちを心から愛していて、きちんと世話をし、守ってやっています。素晴らしいイヌですよ」*と、レオーネ園長は言っています。

猟犬のあたしが獲物の母親にされちまった……

あたし、赤ん坊に弱いのよ

グレイハウンドと、シカ、キツネ、ウサギ

親代わりの楽しさに目覚めて、何度も子育てをする動物もいます。

2003年、イギリスのとある町で、ガーデニング用品入れに閉じこめられていた若いメスのグレイハウンドを警察官が保護しました。そのやせ細って泥だらけの姿を見れば、ずっと虐待されていたことはすぐにわかりました。

警察から連絡を受けたヌネートン・アンド・ワーウィックシャー動物保護センターのジェフ・グルーコックは、すぐにグレイハウンドを引き取りました。ジャスミンと名づけたその犬が健康を取り戻し、また人間を信頼できるようになったらもらい手をさがしてやろう、とグルーコックは考えていました。

ところが、元気になったジャスミンはグルーコックのあとをついて歩くようになり、新たに保護されてくる動物をすすんで出迎えるようになりました。特に幼い動物には強い興味を示しました。

そのまま施設にとどまったジャスミンは、キツネやアナグマ、鳥のひな、モルモットやウサギまで、いろいろな動物の母親代わりとなりました。

ジャスミンの母親ぶりをよく表しているのが、ある子ジカとのエピソードです。近所の住人から、保護センターに近い野原で子ジカが鳴いていると連絡がありました。どうやら母親を殺されたらしくパニック状態のその子ジカは保護され、ブラン

48

グレイハウンドはほかのイヌにくらべて脚がとても長く骨ばっているので、おすわりは難しいようです。

あたし、赤ん坊に弱いのよ

49　おかあさんになった犬

あたし、赤ん坊に弱いのよ

ブル（野バラ）という名前をもらいました。

おびえったブランブルを優しく出迎えたのは、ジャスミンでした。

「ふたりはいつもいっしょでした。散歩するときは必ず、ジャスミンのそばにぴったりとブランブルがいるんです。折にふれてキスするふたりの姿には、見ているこちらも癒されましたよ」と、グルーコックは言います。

ジャスミンはどんな動物の子どもでも同じようにかわいがりました。猟犬であるグレイハウンドなら狩りの獲物にするはずの、ウサギの子どもまで。自分の鼻先に鳥が止まっても、ジャスミンがじっとしていたことを、グルーコックは覚えています。

「あれには驚きましたよ。グレイハウンドというのは普通、攻撃的な犬種なんです。ドッグレースに使われるようなイヌですから。でもジャスミンはどんな動物にも、わが子のように愛情を注いでいました」*

幼い動物たちがあっという間に施設になじんだのは、ジャスミンがそれぞれに見合った方法で世話をしたからでした。おびえた動物にそっと寄りそって落ちつかせ、虐待されて傷ついた動物を慰め、みんなが早くなじめるように導いたのです。動物たちはジャスミンに心を許したことをきっかけに、グルーコックやスタッフを信頼できるようになりました。

残念ながら、ジャスミンは２０１１年に亡くなりました。いろいろな動物の良き母親代わりであったその思い出は、いまも語り継がれています。

あたし、赤ん坊に弱いのよ

51　おかあさんになった犬

だって、体の柄がそっくりだったんだもん

ダルメシアンとヒツジ

オーストラリアのバロッサ・バレーで牧場を経営しているジョンとジュリーのボルトン夫妻は、ダルメシアンのブリーダーでもあります。長年牧場で暮らし、いろいろなイヌやヒツジを見てきた夫妻でも驚いたという、あるダルメシアンと子ヒツジの親子がいます。

あるとき、1頭の母ヒツジが生まれたばかりの子ヒツジの世話をやめてしまいました。

そこで夫妻は、発情期をむかえながら妊娠できなかった、ダルメシアンのゾーイーに子ヒツジを引き合わせました。

母親になれなかったゾーイーは、親に見捨てられた子ヒツジを放っておけなかったのかもしれません。

「ゾーイーは子ヒツジの体をすみずみまで舐めてやり、出ない乳をふくませようとさえしました。でも結局、ミルクはわたしが哺乳びんで与え、そのほかの世話はゾーイーがするようになったのです」と、ジュリーは言います。

じつはその子ヒツジはドーパー種とヴァン・ルーイ種の掛けあわせで、体の柄がダルメシアンそっくりでした。

「このヒツジはきっとダルメシアンの子どもだよ。新種だから『シープメシアン』と

だって、体の柄がそっくりだったんだもん

> ダルメシアンは馬とは相性がいい犬種です。消防道具を馬車にのせていた時代から、消防署で飼われていたからです。消火活動のあいだは馬をなだめておく役割を担っていたそうです。

> だって、体の柄がそっくりだったんだもん

でも呼ぼうかな、それとも『ダルドーパー』がいいかい」と、ジョンがジョークにしたほどです。*

「みごとな白黒模様でしょう。白地に黒い点が散っていて、ほんとうにダルメシアンそっくり」と、ジュリーも面白がっています。

子ヒツジはかたときもゾーイーのそばを離れませんでした。自分をイヌだと思っていたのか、ヒツジだと思っていたのかはわかりませんが、子ヒツジにとってはそんなことはどうでもよかったのでしょう。

子ヒツジは夜になるとダルメシアンの犬舎に帰り、「お母さん」の隣でぐっすり眠っていました。

ご注意！ しがみつくクセは治りません

ミックス犬とショウガラゴ

イギリスのスタッフォードシャーにある小さな動物園で、1匹のショウガラゴの赤ちゃんが生まれました。

けれども、母親は赤ちゃんの世話をしようとしませんでした。

それは動物園暮らしの霊長類にはけっして珍しくないことでしたが、赤ちゃんを育てる飼育員は頭をかかえました。ショウガラゴの子どもはほかの動物を育てるようなわけにはいかないからです。

その理由のひとつは、ショウガラゴが夜行性であること。それにもうひとつ、赤ちゃんが心身ともに成長するためには、起きている時間のほとんどを親にしがみついている必要があるということです。

とりあえずは何かにしがみつかせようと、飼育員はふわふわしたぬいぐるみや、お湯の入ったびんに毛皮を巻きつけたものなどいろいろ試してみたのですが、赤ちゃんはどれも気に入りませんでした。

そこで母親代わりとして白羽の矢が立てられたのが、動物園に暮らすメスのミックス犬、ジュディでした。ジュディ自身も親に捨てられたイヌなので、ショウガラゴの赤ちゃんの気持ちがわかってやれるかもしれないと飼育員は思ったのです。

手始めに、しがみつかれることを嫌がらないかどうか、テストをしました。

▶ ご注意！ しがみつくクセは治りません

おかあさんになった犬

ショウガラゴには舌が2枚あります。上側の1枚は物を食べるために使いますが、下側の1枚は少し小さいです。これは軟骨のようなもので、毛づくろいをするのに使います。

ご注意！ しがみつくクセは治りません

> ご注意！ しがみつくクセは治りません

ふわふわの温かいものがまるで帽子のようにずっと頭にくっついていても、ジュディは気にしていない様子で、嫌がって頭から振り落としたりもしませんでした。ジュショウガラゴの赤ちゃんも、しがみついたところがほどよく温かいので、安心しているようでした。

問題点がひとつクリアされて手ごたえを感じた飼育員は、つぎに飼育部屋の照明をつける時間を少しずつずらし、だんだん日中に部屋が暗くなるようにしました。飼育小屋の明るさが完全に昼夜逆転すると、飼育員は通常の勤務時間内に夜行性のショウガラゴの世話をすることができるようになりました。

親代わりのジュディも、暗い部屋のなかの生活に慣れました。赤ちゃんの健康チェックとあわせて、ジュディの頭が赤ちゃんの爪で傷ついていないかどうかも、飼育員の日々のチェック項目になりました。

数々の努力がみのり、弱々しい赤ちゃんだったショウガラゴはすくすくと成長しました。そこで、小型の哺乳びんで与えていたミルクをやめ、大人のショウガラゴと同様に虫を食べさせることになりました。

大きくなったショウガラゴは、ずっとしがみついていたことで手足の力が強くなったので、どこへでも自由に動きまわれます。えさを食べ終わると、腹ごなしに壁へ8フィートもジャンプするほどです。

けれども幼いころの習慣が抜けないショウガラゴは、なにかにつけてジュディの頭にしがみつくのでした。

最後は命がけの子育てだったよ

ボーダーコリーとミニブタ

ブルークロスといえば、イギリスで最大規模の非営利動物愛護団体です。長年、さまざまな動物を受け入れてきた経験を活かし、イギリス国内に数多くある保護施設に動物病院を併設して、ペットの病気の診察や、トレーニング指導を行っています。

1997年4月、イギリスのヘイスティングス近郊にあるその動物病院に、生まれたばかりのミニブタの子どもが4匹連れてこられました。母親が育児放棄したというのです。

獣医師のリズ・グラントが急いで子ブタたちを布でくるんで温め、ミルクを与えているところへ、動物病院の顔でもあるメスのボーダーコリー、マックが騒ぎを聞きつけてやってきました。

「マックはすぐに子ブタたちに寄りそい、優しく舐めて緊張をほぐしてやりました」

子ブタたちはすぐマックに慣れ、それからは食べることも遊ぶこともすべてマックに教わりました。「マックのおかげで、命を取りとめたのです」*

ミニブタは頭が良く、イヌの真似をして「歩け」「そばにつけ」「取ってこい」などのしつけや芸を覚えることがあるといいます。

だからもしかしたら、マックに育てられた子ブタたちがいつのまにか子育てを覚えていて、母親に捨てられた子イヌの親代わりをすることもあるかもしれませんね。

58

> 純血種のミニブタは、普通の豚よりかなり小さい大きさにしか成長しません。だから中型犬と同じくらいになったというミニブタには、どこかで普通の豚の血が入っているはずです

最後は命がけの子育てだったよ

おかあさんになった犬

60

世界を救うのはきっと、母性なんですね

ラブラドールとコビトカバ、トラ、ヤマアラシ

いろんな動物の赤ちゃんをつぎつぎに育てるイヌの話は、本書のなかでもいくつか紹介していますが、南アフリカ共和国にもそんなイヌがいます。

カンゴ野生動物牧場は、いろいろな動物とふれあうことができると人気の観光スポットです。観光客のお目当ては、たくさんの動物の母親代わりをしているラブラドールのリーシャです。

リーシャは牧場を経営するナディーンとロブのホール夫妻が飼っているイヌです。親を亡くして牧場に保護された動物の子どもは、どんな種類でもみな、リーシャが育てています。

スタッフが動物の子どもを箱に入れて運んでくるのを見つけると、リーシャは駆け寄っていくのです。

「赤ちゃんが連れてこられると、自分の出番だと思うみたいですね。どんな動物の赤ちゃんでも、すぐに鼻先を寄せて舐めてやるんですよ」*

10才になるリーシャはこれまで、トラをはじめコビトカバ、ヤマアラシまで、いろいろな動物の子どもを30頭以上も育ててきました。

ホール一家はリーシャをまだ子イヌのころから見ていますが、どんな動物の子どもにでも母性本能を発揮する姿には、いまでも驚かされるといいます。

▎世界を救うのはきっと、母性なんですね

アメリカン・ケンネル・クラブが選ぶアメリカで人気の犬種ランキングでは、ラブラドール・レトリバーが20年連続で1位を独占しています。

▼世界を救うのはきっと、母性なんですね

世界を救うのはきっと、母性なんですね

「相手がネコでもヤマアラシでも、わけへだてなく世話をするんですからね。でもさすがに、ヤマアラシの子どもを舐めていたときは、わたしたちもちょっとはらはらして見ていましたけど」*

すっかりお母さん役が板についたリーシャですが、じつは自分の子どもを産んだことはないといいます。

何度も子どもを産んでいても、ほかの動物の子どもは見向きもしないという動物の親もいます。でも、リーシャが母親代わりを引き受けなかったことは一度もありません。

「赤ちゃんはみなリーシャになつきます。そして大好きなリーシャがわたしたちを信頼している様子を見て、少しずつ人間にも慣れていくのです」**と、飼い主のナディーンは言います。

リーシャは牧場生まれの子どもたちの面倒もみています。何かしらの理由で、親が育児をやめてしまった子どもたちです。

牧場生まれの子どもたちは、生後数日のころから、野生動物とはくらべものにならないくらい人間とふれあいます。そのため、そばに母親がいない子どもたちは、人間に慣れすぎたり、自分を人間だと思いこんだりすることがあります。

でも母親代わりのリーシャがついていれば、子どもたちは動物らしい本能や警戒心を持って成長することができるのです。

63　おかあさんになった犬

この子が大好き！

あたしを捨てた実の母よりどれだけいいか

グレートデンとシカ

イギリスのサマセット州にあるシークレット・ワールド野生動物保護センターには、病気やけがをした動物が運びこまれた場合の鉄則があります。それは、キツネでもフクロウでもアナグマでも、とにかくドアをくぐった瞬間に救急チームが駆けつけて手当てをすること。

できるかぎりの手をつくし、もとの健康を取り戻したら必ず野生に返すことが、このセンターの目的なのです。

あるとき、生まれてすぐ母親に捨てられたと思われる、生後数日の子ジカが運びこまれました。もちろんスタッフはすぐに対応しました。

「かなり危ない状態でした」と、1984年に夫とともに保護センターを立ち上げたポーリーン・キドナーは言います。

「子ジカはびしょぬれで、その体は冷えきり、意識もほとんどなかったのです」*

それから1週間、懸命の手当てを受けた子ジカは少しずつ回復しました。そこでキドナーは子ジカを中庭に出し、様子を見ることにしました。

シンディと名づけられた、まだ弱々しいその子ジカが庭を歩く姿を見て、自分が守ってやらなくてはとひそかに決意を固めたイヌがいました。キドナーの息子が飼っていたオスのグレートデン、ロッキーです。

あたしを捨てた実の母よりどれだけいいか

シカは生まれて20分で立ちあがり、1時間後には歩けるようになります。

67

あたしを捨てた実の母よりどれだけいいか

あたしを捨てた実の母よりどれだけケイいいか

ロッキーは日ごろから保護センターを歩きまわり、新入りの世話役をかって出ていました。

不思議なことに、好意を寄せたのはロッキーのほうばかりではなかったようです。シンディがセンターに来て2週間たつころには、散歩に行くときは必ずふたりいっしょに歩くようになっていました。

「ロッキーの世話の焼き方はまるで過保護な母親のようで、シンディはわたしよりもオスのロッキーを母親とみなしていると思います」と、キドナーは面白がっています。

ロッキーはシンディが危険な目に遭わないよう、つねに目を光らせています。とはいえ、まだ幼いシンディは、ときにひとり気ままな冒険に出かけてしまうこともあります。でもロッキーがそばにいないと気づくと、あわてて駆けもどり、甘えて体を寄せるのです。

「ほほえましい親子ですよ」と、キドナーは言いました。

同情のつもりが愛情に変わったということかもね

ボクサー犬とブタ

イギリスのノフォークにあるヒルサイド動物保護センターの設立者、ウェンディ・バレンタインは、虐待された動物に惜しみない愛情を注いでいます。

センターのスタッフも保護された動物の健康を取り戻すために手をつくしていますが、思わぬところから助け舟が出ることも、ときにはあるのです。

2011年のクリスマスも近づいたある日、センターの近くで、生まれてまだ数時間ほどの子ブタが保護されました。

「本当に小さくて、へその緒がついていたんです」と、バレンタインは振り返ります。

見つかった場所を考えると、おそらく養豚場から食肉用として売られていくブタがトラックの荷台で産気づき、生まれた子ブタがそのまま路上に転げ落ちてしまった、というところでしょう。

「つきっきりで世話をする必要があったので、タビサという名前をつけたその子ブタをわたしの家に連れて帰りました」

バレンタインの家には、その数年前にウェールズの繁殖業者のもとから保護した5才のボクサー犬、スージーがいました。帰宅したバレンタインを出迎えたスージーは、主人の抱いていたタビサを見て喜びました。

「タビサも、スージーを母親と思ったようでした」と、バレンタインは言います。

ブタの体には汗をかく機能がありません。そこで体温を下げるために、泥のなかを転げまわるのです。

■ 同情のつもりが愛情に変わったということかも ね

「家で余っていたバスケットを寝床にしてやったのですが、タビサはまだ幼いので自分でそこから出ることはできませんでした。スージーはそのバスケットをのぞきこんで、四六時中タビサに鼻をすり寄せていましたよ*」

タビサはあっという間に成長して、体はスージーと同じくらいまで大きくなりました。でもふたりの様子は初めて会ったときとまったく変わらないといいます。

「あれからずっといっしょにいるというのに、まだ寝るのもいっしょなら食べるのもいっしょなんですからね」と、バレンタインは苦笑します。

「でもその様子を見ていると心が癒されます。ふたりでひとつなんでしょうね。体が大きくてもまだまだ子どもだとわかっているのか、スージーはとにかくタビサに優しいですよ。追いかけっこをしたり、転げまわって遊んでいるふたりを見ると、わたしも自然と笑顔が浮かんでしまうんです**」

72

そうか、ぼくの前世は犬だったかも

ミックス犬とアナグマ

1998年の春、イギリスのサマセット州で保護されたアナグマの赤ちゃんは、オス犬の愛情に二度、助けられたと言っても過言ではありません。

とある田舎道で、1頭のオス犬がアナグマの赤ちゃんを見つけました。オス犬はかわいそうに思ったのか、そっとその赤ちゃんをくわえ、飼い主夫妻のもとへ連れてきました。

そのまま放っておいたとしたらアナグマの赤ちゃんはきっと死んでいたでしょう。やせ細った赤ちゃんは、何か食べ物はないかと必死であたりのにおいを嗅いでまわり、えさ代わりに出された野菜くずをものすごい速さでがつがつと食べました。

オス犬の飼い主夫妻はその様子を見て、どれほどつらい思いをしたのだろうとやりきれない思いでいっぱいになりました。

イヌが赤ちゃんを連れてくる少し前に、家の近くで死んだアナグマを見かけていたので、その子どもだということは察しがつきました。

そこで夫妻は、いちばん近い保護施設であったシークレット・ワールド野生動物保護センターに連絡を取りました。アナグマの赤ちゃんはすぐに保護されることになりました。

保護センターで出迎え役を務めている4才のオスのミックス犬、マレーは、アナ

アナグマは夜行性の雑食動物です。穴を掘ることにかけては人間よりずっと速いです。

そうか、ぼくの前世は犬だったかも

グマの赤ちゃんをひと目見るとすぐにスタッフを押しのけて近寄り、自分が父親代わりになるという意思をはっきりと示しました。
ジャーマン・シェパードとドーベルマンのミックスであるマレーと、デイヴィッドという名前をもらったアナグマの赤ちゃんは、お互いに肩やお尻をすりつけてすぐ仲良くなりました。
「オス犬に命を助けられ、また別のオス犬のもとですくすく成長しているアナグマなんて、デイヴィッドぐらいでしょうね」と、保護センターのポーリーン・キドナーは言います。
「デイヴィッドはきっと、生まれ変わったらイヌになると思いますよ*」

いやあ、子育てというのは大変なんですよ

チワワとマーモセット

イギリスのフィッシャー男爵夫妻は、ノフォークに所有するキルヴァーストーン・ホールと呼ばれる邸宅の一角に小さな動物園を設け、南米の絶滅危惧種の動物を保護し、繁殖させる活動に取り組んでいます。そこで繁殖が行われているマーモセットの群れでは、始終けんかが絶えませんでした。

どこの動物園でも、群れのなかのいざこざはあたりまえのことですが、繁殖でやっと生まれた1匹の赤ちゃんに危険が及ばないよう、何か対策する必要がありました。

そこで日中、群れから赤ちゃんを庭へ連れ出し、日光浴をさせるために、ベビーシッター役のイヌをつけることになりました。

マーモセットの赤ちゃんは自分より大きくて毛皮のある動物にしがみつくことで、体が温められ、成長が促進されます。イヌの背中はまさにその役目にぴったりでした。

ところが、ベビーシッターに選ばれたチワワのサムにとって、それはとてつもない重労働でした。体重1.3キロ程度の小型犬にしてみれば、たった85グラムの赤ちゃんでも特大の荷物なのです。それに必死でしがみつかれて鋭い爪が食いこむのは、けっして気分のいいものではありませんでした。

幸い、サムには交代がいました。もう1頭、ゴールデン・レトリバーのベビーシッターも待機していたのです。

76

ゴールデン・レトリバーにマーモセットの赤ちゃんを引き渡すと、サムはほっと大きくため息をつくのでした。

> もともと、チワワは貴婦人が連れて歩くための愛玩犬としてつくられた犬種です。大きさだけでなく、一日中、人間のそばにいることが大好きな性格で愛されてきました。

父性はそのまま母性にもなるってことさ

ボーダーコリーとハイエナ、トラ

南アフリカ共和国のシービュー・ライオン・パークに暮らすソロは、トライカラーのオスのボーダーコリーです。

「ソロはパークでトラに囲まれて育ちました。えさはトラの子どもと同じものでしたから、よく取り合いをしていましたね。あまりにも横取りされるときには、トラの子どもにがぶっと嚙みついて、自分のボウルに戻らせていましたよ」*と言うのは、ソロの飼い主でパークの責任者でもある、アシュリー・ゴンバートです。

オスながら育児本能がとても強いソロは、トラといっしょに育ったせいか、ほかの動物の子どももわけへだてせず世話をしています。

「新入りが来ると、ソロが必ず舐めにやってくるんですよ」

牧羊犬であるボーダーコリーは元気いっぱいなことが特性なのに、パークには追いかけ回せるようなヒツジがいないのですから、ソロがありあまるエネルギーを子育てに向けるのはしかたのないことかもしれません。

「パークに親のいない子どもが入ってくると、ソロは人間がきちんと世話をしているか、まるで監視するようにじっと見ています」とゴンバートは言います。

あるとき、ソロは親に捨てられた生後4か月のトラの双子、ジュードとルビーの父親代わりを引き受けようと、子どもたちをていねいに舐めていました。

ハイエナの赤ちゃんは、1才になるころまで母親のお乳で育ちます。

父性はそのまま母性にもなるってことさ

79　この子が大好き！

父性はそのまま母性にもなるってことさ

ところが、人間たちが健康診断のためにジュードとルビーをソロから取り上げたちょうどそのとき、親を亡くしたハイエナの子どもたちが運びこまれました。
するとソロは、ハイエナの子どもたちもすぐに舐め始めたのです。
ソロはトラもハイエナもまとめて育てることになりました。
トラやハイエナの子どもたちが遊んでいるところを眺めていたソロが、突然ボーダーコリーの本領を発揮することがあります。
「子どもたちが離れたところへ行くと、ソロはものすごい速さで飛んでいって近くへ戻らせます。ヒツジを集めるような追いかけ方ですが、それは父親としての愛情の表れなんですよ」と、ゴンバートは目を細めました。

命にかかわるときは、ペットも野生もないって

ミックス犬とカンガルー

オーストラリアのビクトリア州に住んでいるレオニー・アランが飼っているのは、短い巻き毛が愛くるしいジャーマン・ポインターのミックス犬、レックスです。

「もう10才ですから、何をしてもかわいいというわけじゃないですよ。いたずらもするけれど気の優しい、愛情にあふれたごく普通のイヌです」と飼い主のアランは言います。

ある日、いつもどおり朝の散歩をしていたアランとレックスは、道端でカンガルーが1頭車にひかれて死んでいるのを見かけました。

かわいそうですが、オーストラリアのこの地域では特に珍しいことではありません。じきに役場の人が片づけに来るだろう、とアランは気にもとめませんでした。

散歩から戻って、そのまま庭仕事をしようと思ったアランは、家には入らず庭でレックスのリードを外しました。

とたんに、レックスは庭から飛び出していきました。すぐに戻ってきたレックスは、口に何かくわえていました。

「ヘビでも捕まえてきたのかと思って、嫌だって叫んでいるわたしの足もとにレックスが置いたのは、小さなカンガルーでした」

それは道端で死んでいたカンガルーのお腹の袋にいた赤ちゃんでした。

生まれたばかりのカンガルーの子どもは、豆粒ほどの大きさしかありません。そのまま母親の袋のなかで7、8か月過ごしてから、外の世界に出てきます。外に出たあとも、1才になるころまでは、母親のお乳を飲んで育ちます。

命にかかわるときは、ペットも野生もないって

「レックスはきっと、カンガルーの袋のなかで赤ちゃんが生きていることを感じとったのでしょう。そっと赤ちゃんの首のうしろをくわえて引っぱり出し、わたしのところへ運んできたのです」

レックスが赤ちゃんカンガルーを舐めてやると、じきにカンガルーは元気を取り戻しました。

レックス・ジュニアと呼ばれるようになった生後4か月の赤ちゃんカンガルーは、アランのもとで数日過ごしました。ふたりは仲良くいっしょにジャンプして遊んでいました。

レックス・ジュニアはその後、ジラウリンガ・コアラ野生動物保護センターに引き取られました。

「カンガルーがレックスを警戒しなかった、というのはすごいことですよ」と、保護センターの所長テリー・ゴードンは驚いています。

「レックスはとても優しくカンガルーを扱い、すぐに人間のところへ連れていきました。きっと家の周りにいる動物をむやみに攻撃しないよう、飼い主さんがしっかりしつけていたのでしょうね。野生動物との共生をイヌにもきちんと教えるべきだという、いいお手本ですよ」*

三つ子だからって見殺しにはできないよ

ボクサー犬とヤギ

ペニーウェル・ファームは、イギリスのデヴォン州にある野生動物保護施設です。

2008年2月、スタッフのエリザベス・トーザーがヤギの飼育小屋をのぞくと、ちょうどメスのヤギが子どもを3匹産んだところでした。

ヤギは生まれた子どもが三つ子だった場合、子育ては2匹で手いっぱいとばかり、いちばんひ弱そうな子の世話をしなくなり、そのまま見殺しにしてしまいます。

そのときも、母親が面倒をみていない子ヤギがいることに気づいたトーザーは、すぐにその子ヤギを救いあげ、体を拭いたり哺乳びんでミルクを与えたりしました。

もちろん、そのままトーザー自身が育てるつもりでした。ところが、弱々しい子ヤギの姿は、飼っていたオスのボクサー犬、ビリーの育児本能を目覚めさせました。ビリーはすぐさまトーザーを押しのけるようにして子ヤギの体を舐めてやり、かいがいしく世話を始めました。

父親代わりとなったビリーは、リリーと名づけられた子ヤギからけっして目を離しませんでした。

「ビリーのそばにはいつもリリーがくっついていました。ふたりが寄りそって寝ている様子や、ビリーがリリーの口元についたミルクを舐めてやる姿は、とてもほほえましかったですよ」*

> ヤギの双子は、性別が違う場合必ずオスが先に生まれます。

三つ子だからって見殺しにはできないよ

この風変わりな親子のおかげで、施設の見学者も増えましたしね、とトーザーはにっこり笑いました。

この子が大好き！

愛してるからさ、離れたくないんだよ

ジャーマン・ショートヘアード・ポインターとコノハズク

アフリカオオコノハズクのケルビムがイギリスにあるデヴォン鳥類保護センターにやってきたのは、まだ生後4週間のころでした。

保護センターでは、トリたちがリラックスできるよう、鳥舎のほか建物内の一部でも自由に飛びまわらせています。

建物のなかにはほかの動物も暮らしていました。なかでもジャーマン・ショートヘアード・ポインターのキエラはよくトリたちを追いかけ回すので、新入りはまずキエラの反応を確認してから建物内に入れるかどうかを決めていました。

ポインターは狩猟犬です。ですからネコやトリなど小型のペットや、食用として室内で飼われることがある大型のフクロウとはあまりうまくいかないといわれています。キエラがフクロウのケルビムに食いついたりはしないか、と保護センターの創設者、カレン・アンドリウナスは少々心配でした。

ところが、キエラはひと目見た瞬間から、愛おしげにうっとりとケルビムを眺めていたのです。

以来、親代わりを自認し、いつもケルビムから目を離さないキエラですが、ちょっとした心配事ができました。

アフリカオオコノハズクは、普通のフクロウの赤ちゃんくらいの大きさまでしか

88

愛してるからさ、離れたくないんだよ

成長しない小型のフクロウです。アンドリウナスが地域の小学校で開いている野鳥の講習会で見せるにはうってつけの大きさでした。

「子どもたちに触らせてあげたくて、ケルビムを学校に連れていくことにしたんです」*

アンドリウナスが講習会で学校へ行く日には、ケルビムが無事に帰ってくるまでキエラはうろうろと建物のあちらこちらを歩きまわり、ずっと落ちつかない様子でいるのです。

メスのフクロウが一度に産む卵は1個だけです。だからフクロウに双子はいません。

大きな犬と小さなモルモットの愛情物語

エアデール・テリアとモルモット

カナダのバンクーバーに暮らすエアデール・テリアのサンシェードは、おそらく世界一辛抱づよいイヌでしょう。モルモットが欲しくて、10年も待ってもらったのですから。

2000年、エレイン・フーは16歳のお誕生プレゼントに買ってもらったエアデール・テリアのサンシェードをとてもかわいがっていました。サンシェードのことを毎日つづるためだけに、新たにブログを開設したほどです。

エレインはえさやおもちゃを買うためにサンシェードを連れて近所のペットショップによく立ち寄っていました。

サンシェードがモルモットのケージの前に来ると必ず立ち止まることには気づいていました。

エアデール・テリアは畑の小動物の駆除に使われる犬種です。モルモットに反応するのは本能のせいかもしれません。

でも、庭でリスやネズミを見つけたときには体をこわばらせ、耳を立てて口をぎゅっと結ぶサンシェードが、モルモットを見るときにはとてもリラックスした様子なのを見て、エレインは好きなだけ眺めさせてやっていました。

それから10年が過ぎ、すっかり老犬になったサンシェードは体調を崩してがんと診断されましたが、その後治療のかいあって再び元気になりました。

エアデール・テリアがテリアの王様と呼ばれるのは、テリア類のなかでいちばん体が大きいからです。

大きな犬と小さなモルモットの愛情物語

92

そこでエレインは回復のお祝いにプレゼントをあげることにしました。

それはもちろん、1匹のモルモットです。

長年、うっとりと眺めるだけだったモルモットを間近に見たサンシェードは、はりきって世話を始めました。その様子を見てエレインもうれしくなり、ひと月後にはもう1匹買ってきました。

サンシェードは毎日、2匹のモルモットの毛づくろいにおおわらわでしたが、とてもうれしそうでした。モルモットたちが自分のそばを離れると、見た目にもわかるほど寂しそうな顔をしたほどです。

しばらくして、モルモットの赤ちゃんが生まれました。2匹はオスとメスだったのです。赤ちゃんはつぎつぎに生まれてきましたが、サンシェードは孫ともいえるその赤ちゃんたちも献身的に世話をしました。

エレインはサンシェードの奮闘に感心し、ブログに毎日その様子を載せていました。

そんなある日、1匹の赤ちゃんモルモットが突然死んでしまいました。エレインはかわいそうに思い、庭先に埋めてやりました。

するとサンシェードは、毎日その場所へ行って、じっと座っていました。数週間、お墓の前でひとり悲しみを癒したサンシェードは気力を取り戻し、またモルモットの世話に明けくれる日々に戻ったのでした。

残念ながら「いじめ」は動物の世界でもあるんだよ

イヌとサル

人間の世界では、学校や近所の公園で子どもが友達にいじめられたら、父親か母親が止めに入るものです。

2008年、中国の河南省にある動物園で、ある子ザルへのいじめを止めたのは、父親代わりのイヌでした。その子ザルは両親を亡くしていました。周りのサルたちはこぞって子ザルをいじめ、ときには大人のサルまで交じって痛めつけては面白がっていたのです。子ザルが殺されそうになったことも一度や二度ではありませんでした。

なんとかしてやりたいと思った飼育員は、サイ・フーという名前のイヌをサル舎でいっしょに飼育することにしました。イヌが子ザルを守ってくれるのではないか、そうでなくても、少しはサルたちの注意をそらすことができるのではないかと思ったのです。

その試みはうまくいきました。

サイ・フーがサル舎に入ると、子ザルはすぐにその背中にしがみつきました。自分の役目は子ザルの父親代わりだ、とすぐにサイ・フーは悟りました。そこで周りのサルたちが子ザルに手を出そうとすると、みずから楯になって子ザルを守ったのです。以来ふたりは、いつもいっしょに過ごすようになりました。

それからはほかのサルたちも、もちろん動物園を訪れるお客さんたちも、ふたりの姿をほほえましく見守るようになりました。

サルが笑顔をつくったり、あくびをしたり、何度もうなずくようなしぐさをするのは、攻撃の前ぶれと考えられています。

おれの趣味は子育てだけど、こんどはアヒルかい？

イエロー・ラブラドールとアヒル

イギリスのエセックスにあるマウントフィチェット城は、国の歴史的建造物に指定されている古城です。中世の城郭とノルマン人の村落を復元した観光名所であると同時に、動物の保護施設でもあり、10エーカーの広大な庭では保護された動物たちが元気に駆けまわっています。

城の管理責任者であるジェレミー・ゴールドスミスは、建物も動物も同様にきちんと保護するよう、全力をつくしています。

2012年の春、キツネに母親を殺されたアヒルのひなが保護されました。

「アヒルの子にデニスという名前をつけたものの、あまりに弱々しかったので、じつは翌朝までもたないだろうと思っていました」と、ゴールドスミスは言います。

そこへゴールドスミスの飼いイヌ、イエロー・ラブラドールのフレッドが通りかかりました。

「フレッドはどんな動物にも優しい子なんです。デニスを見るとすぐに飛んできて、体を舐めてやっていました」

ラブラドールといえばカモ猟に使われる犬種ですが、フレッドはマウントフィチェット城で幼いころからいろいろな動物に親しんで育ちました。ずっと動物の子どもを育てる手伝いをしてきましたし、デニスが保護される少し前にも、子ジカの親

おれの趣味は子育てだけど、こんどはアヒルかい？

> カモ類が冷たい水のなかで泳いでいても平気なのは、脚から下には血管も神経も通っていないからです。

おれの趣味は子育てだけど、こんどはアヒルかい？

 代わりをしていたのです。
 アヒルのデニスは夜にはすっかりフレッドに甘え、どこへ行くにもあとをついてまわりました。以来フレッドはデニスの親代わりとなり、いつもいっしょに遊んでやりました。
 とはいっても、城のそばにある池での水遊びは、デニスのほうがずっと上手です。
「デニスは、フレッドがいなかったらこうして泳いでいられなかったでしょう。きっとフレッドの愛情が、デニスの命を救ったんです」
 ゴールドスミスの見たところ、デニスはフレッドをお父さんではなくお母さんだと思っているようです。
「まあ、フレッド近ごろはやりの『主夫』みたいなところがありますからね*」と、ゴールドスミスは笑います。
「デニスはフレッドが大好きですから、イヌの芸も真似して覚えるかもしれませんね。そのうちわんわん吠えながらネコを追い回すんじゃないでしょうか」

犬猿の仲なんてウソ。とても犬身的なんです

グレートデンとチンパンジー

動物の保護施設をつくったひとたちが夢を実現させてから痛感するのは、それが24時間途切れることのない、雑用と緊張の連続だということです。

1963年、イギリスのワーウィックシャーに、のちにトワイクロス動物園として知られる、チンパンジーなどサル類のための保護施設を設立したモリー・バダムとナタリー・エバンスも、動物保護がどれほど困難な事業かということを思い知りました。

サルの世話に忙殺されるなかでもうひとつ驚いたのは、サルの赤ん坊を育てるのにイヌがとても役に立つということでした。

イヌはサルの赤ちゃんたちのベビーシッター兼遊び相手となり、親代わりとしてバダムとエバンスを助けました。

フレンチ・ブルドッグから雑種犬まで、いろいろな犬種がサルの親代わりに起用されましたが、なかでもいちばん多く使われたのは、優しい気性のグレートデンでした。

「グレートデンは、相手がどんなサルでも同じようにかわいがります。やんちゃな赤ちゃんザルがいたずらばかりしても、びっくりするぐらい我慢づよいのです」と、モリー・バダムは著書『モリーズ・ズー』のなかで記しています。

グレートデンのなかでも、バダムのお気に入りはコーリーというイヌでした。

▶ 犬猿の仲なんてウソ。とても犬身的なんです

グレートデンはイヌのなかでも最も大きい部類に入ります。オスの体重は優に200ポンドを超えますし、うしろ脚で立ちあがると6フィート以上にもなるので、人間を見下ろすこともよくあります。

犬猿の仲なんてウソ。とても犬身的なんです

100

犬猿の仲なんてウソ。とても犬身的なんです

じつはバダムは、保護シェルターでボランティアを引きずるようにして現れたコーリーを見て、そんなに力が強くては自分にはほかのイヌに代えてもらうつもりでいたといいます。

「でも近くに来たコーリーが、大きくて悲しげな目で、どうかチャンスをくださいと訴えかけるので、なんだかかわいそうになったんです。体はがりがりに痩せていました。ペットショップでひどい扱いを受けてきたのだとすぐにわかりました」

引き取られたときは、力が強くて乱暴者に見えたコーリーでしたが、その後は動物園きっての優しい父親代わりになりました。

コーリーが特にかわいがったのは、ミニーというチンパンジーの赤ちゃんでした。「チンパンジーの赤ちゃんはわたしの自宅で飼育しているんですが、コーリーはとても優しく世話していました」と、バダムは言います。

「いっしょになって転げまわったり、追いかけっこをしたりね。チンパンジーがコーリーをからかっても、けっして仕返ししないんです。たとえサルたちに殺されそうになったとしても、きっとされるがままになっていたでしょうね」*

101　この子が大好き！

なぜひよこだって？ おれにだってわからんよ

ケルピー犬とひよこ

オーストラリアのダーウィンという町に住むマリー・ルーシックは、7才のオスのケルピー犬、マレーを飼っています。

マレーはよく勝手に家を抜け出していましたが、いつも日が暮れるまでには帰ってくるので、ルーシックも特に心配したことはありませんでした。

ところがある日、真っ暗になってもマレーが帰ってこなかったので、ルーシックは車で近隣をまわりました。

不安にさいなまれながら何時間も名前を呼んで捜しても見つからず、どうか先に家に帰っていて、とわらにもすがる思いで自宅へ向かったときのことでした。

マレーは近所の家の庭にいました。帰りが遅かったのは、ルーシックが思いもしなかった理由でした。

ひよこと遊んでいたのです。

ルーシックが呼びかけても、マレーはなかなか帰ろうとしません。しばらくなだめたりすかしたりしてようやく、その日は車の助手席に乗りこんで帰りましたが、翌日もまたマレーはひよこのいる家に出かけていきました。

「何度も続くと、さすがにちょっと困ってしまって」ルーシックは言います。

「マレーをご近所の庭に入りこませないためには、うちでもひよこを飼うしかなかっ

102

メンドリは、すでに卵があるほかのメンドリの巣に自分の卵を産むことがあります。ひとつの巣に2羽分の卵があって、メンドリたちが交代であたためているということも珍しくありません

なぜひよこだって？ おれにだってわからんよ

「たんです」

ルーシックが手に入れた2羽のひよこは、偶然にもマレーの黒い毛皮と同じ、黒い羽をしていました。

もちろん、その後マレーは一度も家を抜け出していません。ずっとひよこのそばにつきっきりだからです。

「仕事に出かけるときは、ひよこを入れた箱を家のなかに置いておくと、マレーはそのそばにじっと座っています。帰ってきてから外に出してやると、ひよこたちはそのわきに寝そべるマレーの体に上ったり、マレーの頭から滑り降りたりして楽しんでいますね」

「マレーはいいお父さんだと思います。ひよこが目の届かないところへ行きそうになったら、口でくわえて連れ戻していますし、いつもひよこたちの隣で寝て、おかしな物音がしたら危険がないかすぐ見に行くんですよ」

そのかわり、投げた棒を取ってくるとか、ボールを追いかけて走るとか、そういうイヌらしい遊びはすっかりやらなくなったといいます。

「マレーはすっかりひよこに恋をしてしまったんですね」*

猫たちの新しい家族

種類が違うとはいえ、別れはお互いつらいもの

ネコとライオン

ライオンのザーラは、2008年の春、イギリスのケンブリッジシャーにあるリントン動物園で生まれました。

「この動物園では、動物の子育てにできるかぎり人間が手を出さないようにしているのですが、ザーラの母親はまだ若く、初めての出産だったので、お乳がほとんど出なかったことから手助けが必要になりました」と、園長のキム・シモンズは言います。

このままでは赤ちゃんの命が危ないと判断したシモンズは、ザーラを親元から離し人工飼育に切り替えました。

とはいっても、ザーラを自宅に連れ帰ったシモンズの役目は、哺乳びんでミルクを飲ませることだけでした。

そのあと抱きかかえて眠らせ、体を舐めてきれいにしてやり、甘やかすのは、すべてシモンズの飼っている茶トラのオスネコ、アーニーが引き受けました。

アーニーは父親代わりとして、ネコやほかの動物と生活するためのマナーを、ザーラにみっちり仕込みました。

アーニーとシモンズのもとで暮らしたほんの6週間ほどのあいだに、たった2ポンドの赤ちゃんだったザーラは、体重10ポンドにまで成長しました。

茶トラと呼ばれるオレンジ色の
トラネコは、4対1の割合でオス
のほうが多いです。

▶ 種類が違うとはいえ、別れはお互いつらいもの

元気に成長したザーラは、ほかの動物園に移されることになりました。その別れはどちらにとってもつらかったようです。

「アーニーは、家にライオンの子どもがいるのが好きなんです。わたしも、ザーラが新しいところで幸せに暮らせるなら喜んであげなくちゃ、とわかってはいても、本当は手放したくなかったですね」*

ザーラの行き先はウガンダのエンテベという町にある野生動物の保護センターに決まりました。

そこならネコ科の動物はたくさんいますから、父親代わりのネコに教わったマナーをきちんと守っていれば、ザーラはきっとうまくやっていけるでしょう。

108

だって、アタシはネコなんでしょ？

キツネとネコ

イギリスのノフォークに住む農家のロン・ベイリスは、むかしからキツネが大嫌いでした。飼っているニワトリやイヌ、ネコに悪さをするからです。

ところが、生後6週間のキツネの子が迷いこんできてからは、嫌いと言いきれなくなってしまったといいます。

そのメスの子ギツネは母親とはぐれたらしく、ふらふらと道に迷ってベイリスの自宅のそばまで入ってきました。

いまにも死んでしまいそうな子ギツネを哀れに思ったベイリスは、生卵と牛乳を混ぜたものを飲ませ、台所の棚に簡単な寝床を作ってしばらく置いてやることにしました。

数週間たつと、子ギツネはすっかり元気になりました。

ベイリスは野生に返すつもりだったのですが、子ギツネがいつのまにか家畜たちになじんでいるのを見て、そのまま飼うことに決めました。名前は拾った月にちなんで、エイプリルにしました。

エイプリルはドッグフードやクッキー、人間の食事の残り物をネコやイヌたちと同じボウルで食べて育ちました。農場の生活リズムにもすっかりなじみ、ベイリスが農場の見回りとイヌの散歩を兼ねて出かけるときには、首輪につけたリードをひっ

だって、アタシはネコなんでしょ？

キツネはイヌ科の動物ですが、むしろネコに似ている部分のほうが多くあります。目は細く猫背ですし、逃げるときにはそっと横に動くしぐさも、ネコにそっくりです。

だって、アタシはネコなんでしょ?

だって、アタシはネコなんでしょ？

ぱってイヌたちといっしょに喜々として歩きました。

「キツネにガチョウの番をさせる〈猫にかつお節〉」ということわざもあるので、ベイリスもカモやニワトリの小屋には近づかせないようにしていましたが、エイプリルはトリには目もくれませんでした。

エイプリルはむしろネコみたいだ、とベイリスの妻ジェニーは言います。

「エイプリルはネズミ一匹殺せない子ですよ。自分のことはネコだと思っていますけどね」

ネコに囲まれて育ったエイプリルは、ごく自然に、農場で生まれた子ネコたちの世話をしていました。母ネコもあたりまえのように子ネコをエイプリルに預けています。

「ネコとキツネが仲良くしているなんて珍しいかもしれませんけど、うちの庭ではネコがキツネを追いかけ回していますよ」*と、ジェニーは言います。

ふんわりふさふさの感触もネコっぽかったのかな

ウサギとネコ

メラニー・ハンブルはスコットランドのアバディーンで動物病院を開いています。病院には、迷いイヌ・迷いネコをはじめ、飼い主に捨てられたさまざまな動物がたくさんやってきます。

ハンブルはそういった動物にはできるかぎりの手をつくして健康を取り戻させ、もらい手をさがしてやるようにしています。

2007年の秋、ハンブルのもとに母親が面倒をみなくなったという生後5週間の子ネコの兄弟が連れてこられました。

自宅で飼っているネコが母親代わりになってくれるだろう、とハンブルは子ネコたちを連れ帰りました。ところが、ネコは見向きもしませんでした。

ネコに代わってその子ネコたちを引き受けたのは、メスのウサギ、サマーです。サマーはずっと庭で飼っていたのですが、そのころ近くで大きな花火大会が行われる予定があり、ウサギが花火に驚いて逃げ出してはいけないと思ったハンブルは一時的に室内に入れていました。

子ネコたちをいじめたりしないかというハンブルの心配をよそに、サマーはすんで母親代わりになってくれたのです。

サマーは子ネコたちといっしょに、そのまま室内で飼われることになりました。

112

ペットとして飼われるウサギの寿命は、12年くらいです。

ふんわりふさふさの感触もネコっぽかったのかな

ふんわりふさふさの感触もネコっぽかったのかな

数時間おきにスポイトでミルクを与えるのはハンブルがしましたが、サマーが子ネコたちのそばにいてそのほかの世話をしてくれなかったら、なかなか大変な仕事だったことでしょう。

「子ネコたちはサマーを本当のお母さんだと思っていました」とハンブルは言います。「サマーは大きめでぽっちゃりしたウサギなので、幸せそうにじっと座っているだけでしたが、その体に子ネコたちがよじ登って遊んでいる様子は、とてもほほえましかったですね」*

やっぱり似た者どうしの心地よさってあるんだね

ネコとひよこ

先に挙げたダルメシアンと白黒まだらの子ヒツジのように、外見が似ているほうが親子の関係になりやすいのかもしれない、という例をご紹介しましょう。

2007年、ヨルダンのアンマン近郊の町で話題になった、7匹のひよこを育てたネコがいます。そのきっかけは、まさに外見が似ていたことでした。にもかかわらず、自分の毛皮とまったく同じ色あいの、赤味をおびたオレンジ色のひよこたちの母親代わりも引き受けたのです。

1才の母ネコ、ニムラは4匹の子ネコを育てていました。

ニムラにとっては、自分の毛皮が少し外側に広がっているように見えたから、近くに寄せた、というくらいの感覚だったのかもしれません。

さすがにひよこに乳をやったりはしませんでしたが、ニムラは子ネコもひよこも自分の子どものように大切に扱いました。

自分のそばをふらふらと離れていくひよこがいれば、ニムラは何をおいてもすぐに追いかけ、そっとくわえあげて、子ネコとひよこが身を寄せあっている箱のなかへ戻してやるのでした。

やっぱり似た者どうしの心地よさってあるんだね

> ニワトリの安静時の心拍数は、毎分250から300。ちなみに健康な人間の安静時の心拍数は、毎分60から100です。

猫たちの新しい家族

魔法のシャネル5番

ネコとリス

始まりは、いつもと変わらぬ朝でした。

イギリスのウエストサセックスに住むレベッカ・ヒルは、3人の子どもにつきそって学校まで歩いていましたが、途中で目に入った子リスのことがずっと頭から離れませんでした。生まれたばかりのようなのにそばには母親もおらず、いまにも死んでしまいそうだったのです。

動物好きのレベッカは子どもたちを学校に送るとすぐ子リスのもとへ戻り、自宅に連れて帰りました。急いで哺乳びんでミルクを与えたものの、子リスはどうしても飲みこもうとしません。学校から帰った子どもたちからチェスナットという名前をもらった子リスは、すでに一刻を争う状態でした。

そこでレベッカの夫、マーティンが名案を思いつきます。家で飼っている2匹のネコ、シュガーとスパイスはどちらも子ネコを産んだばかり。合わせて10匹いる子ネコのなかに子リスがいても、誰も気づかないんじゃないか？ 自分の子どもでなくてもお乳をやっている母ネコたちだから、きっとチェスナットのこともまとめて面倒をみてくれるさ、と。

かかりつけの獣医に問い合わせ、リスにネコの乳を飲ませても問題ないことは確認しました。

生まれたばかりのリスには毛皮も歯もありません。リスの種類にもよりますが、生後2か月くらいまでには毛皮も歯も生えそろい、10か月から18か月で大人になります。

魔法のシャネル5番

マーティンはうまくいってほしいと祈るような気持ちで、レベッカの使っている香水を数滴、子リスに落としました。慣れ親しんだ香りがすればネコたちも警戒しないだろうというわけです。

「ちょっとした賭けでしたが、とにかくリスのにおいを消したほうがいいと思って。妻がいつもつけているシャネルの5番は、ネコたちも気に入っているみたいでしたから」

シャネルの香りがただようチェスナットを子ネコのなかにまぎれこませ、家族はそっと見守りました。

マーティンはそのときのことをよく覚えています。「子ネコたちにいじめられはしないかと心配していたんですが、チェスナットは幸せそうにネコのお乳を飲んでいました」

数日のうちには、シュガーもスパイスもわが子同然に子リスの毛づくろいをしていました。それからチェスナットはぐんぐん成長し、果物やナッツ、ポップコーンを食べるまでになりました。

「チェスナットはきっと自分のことをネコの兄弟のひとりだと思っていますよ。そのくせリスらしく、自分でえさを探したりもしますがね」

母ネコたちがどうしてチェスナットを家族の一員にむかえ入れたのか、マーティンにはわかる気がしています。「じつはシュガーとスパイスは、ビニール袋で捨てられていたのをわたしたちが拾って育てたんです。捨てられた悲しみを知っていたからこそ、母ネコたちはチェスナットを受け入れたのでしょう」*

魔法のシャネル5番

121　猫たちの新しい家族

自分の子どもを亡くしたらネコだって淋しいのよ

ネコとカモ

2007年、埼玉県に暮らす3才のニホンネコ、ヒロコは3匹の子ネコを産んだのですが、残念なことにどの子も数日のうちに死んでしまいました。飼い主のエンドウノリオ・ヨシコ夫妻もそのことに気づいてはいましたが、ちょうど農家の仕事が忙しい時期で、ヒロコを慰めてやることもできませんでした。

同じころ、夫妻の家ではカルガモのひなが卵からかえったばかりでした。長年の経験から、トリとネコを同じ場所に置くと大変なことになるとよく知っていた夫妻は、子ガモたちを離れの小部屋に入れることにしました。

ところがある日、子ガモの部屋にヒロコが入ったことに気づかないまま、夫妻はドアを閉めてしまいます。

あとからまた子ガモの世話をしに戻ると、そこにネコの姿があるではありませんか。夫妻は子ガモを守らなければとあわてましたが、すぐにそんな必要はないと悟りました。子ガモのそばにいるヒロコは、まるで自分の子どもを見守るような優しいまなざしをしていたからです。

エンドウ夫妻には、ヒロコの気持ちがわかる気がしました。自分の子どもを亡くしたばかりのヒロコは、やるせない気持ちをぶつける先がなくて、子ガモたちの世話をせずにいられなかったのでしょう。

ちょうど目が開いたばかりの子ガモたちも、ごく自然に毛づくろいをしてくれるヒロコの姿を見て、母親と思いこんでいました。
ヒロコにとっても子ガモにとっても、それは文字どおりひと目ぼれだったのです。

▸ 自分の子どもを亡くしたらネコだって淋しいのよ

> くわっくわっと鳴き声をあげているカモがいたら、それはおそらくメスです。オスのカモはほとんど声を出しません。

猫たちの新しい家族

自分の子どもを亡くしたら、ネコだって淋しいのよ

豚のお乳を飲むと豚になってしまうというハナシ?

ブタとネコ

農場で飼われているネコの仕事は、万国共通です。それは、家畜のえさを荒らす小動物を退治すること。だから農場ネコの家はたいてい家畜小屋です。

飼い主が、冬のあいだだけ、などと期間限定で家のなかに入れてやることもあります。そんな夢のようなお誘いを、きっぱり断ったネコがいるといいます。イギリスのノフォークにある農場でブタ小屋に暮らしていた、メスのトラネコです。

そのトラネコは、出産したばかりの母ブタが横になっているわらを集めて寝床を作り、子ネコたちを産みました。

それを知った農場主のウィリアム・ヘッドレーは、大きなブタのそばでは子育てしづらいだろう、とネコたちを家のなかへ移してやりました。

ところがトラネコはすぐに、子ネコたちを母ブタのそばのわらへ戻してしまったのです。

ブタたちもネコの一家を歓迎しました。というより、ブタ小屋にはネコがいるのがあたりまえでしたから、にぎやかなほうがよかったのです。

ブタの一家とネコの一家が仲良く暮らし始めてしばらくたったある日、子ネコたちのなかの1匹が、子ブタのなかにまぎれこんでしまいました。すると母ブタは嫌がりもせず、いっしょにお乳を飲ませてやりました。

▶ 豚のお乳を飲むと豚になってしまうというハナシ?

イギリスでは、子ネコの集団を「キンドル」、大人のネコの集団を「クラウド」と呼びます。

豚のお乳を飲むと豚になってしまうというハナシ?

それからというもの、なぜかその子ネコだけがいつも子ブタたちの輪のなかでいっしょに遊ぶようになりました。

その後、成長した子ネコの兄弟はつぎつぎに近所の家へもらわれていきました。でもブタと仲良しの子ネコだけは、農場に残されました。

よその家にあげても、また母ネコに連れ戻されてはかなわないからね、とヘッドレーは苦笑していました。

母ネコとふたり暮らしになった子ネコですが、ほとんどの時間はブタ一家のもとで過ごしています。とはいえ、兄弟のように育った子ブタたちはみな、もうとっくに子ネコより大きくなってしまっているのですがね。

母親に捨てられたイヌたちがネコの家族になった

さび猫とロットワイラー

2007年、イギリスのノフォークで、スカイという名の母ネコが4匹の子ネコを産みました。スカイは茶色とオレンジ、黒、そしてほんの少しの白が混じった毛色の、さび猫でした。

飼い主の動物愛好家、デイヴィッド・ペイジは、うれしくて日に何度も子ネコたちを眺めていました。

偶然にも、スカイの出産から数日たったある日、ペイジが飼っているロットワイラーも、庭で6匹の子イヌを産みました。

ところが、母親業にいそしむスカイとは対照的に、母イヌは生まれた子どものそばから離れてしまいました。

母イヌはきっと出産の苦しみに耐えられず、育児放棄したのだろうと察した飼い主のペイジは、ロットワイラーの子イヌたちを抱きあげ、近くの獣医のもとへ急ぎました。

獣医はぐったりとした子イヌたちを診察し、すぐに抗生剤を投与しました。残念ながら、ペイジが見つけたときにはすでに手遅れだった、子イヌたちのうちの2匹はそのまま肺炎で死んでしまいました。

ペイジは残された子イヌたちを母ネコのスカイに預けようと思いました。

さび猫にオスが生まれることは極めてまれです。

母親に捨てられたイヌたちがネコの家族になった

「4匹になった子イヌたちを、スカイのそばで眠る子ネコたちのあいだに1匹ずつ、ネコとイヌがたがい違いになるようにそっと入れたんです。子イヌたちはすぐにスカイのお腹の下にもぐりこみました」*

子イヌたちはスカイの体温で体が温まると、お乳を飲みはじめました。

それを見守っていたスカイはまるで、さあどんどん飲みなさい、と励ましているようでした。

「ネコがイヌを育てるなんて、あとから思えばすごいことですね」と、ペイジは言います。

「スカイは本当に優しい、素晴らしい母親です。子ネコも子イヌもみな自分の子どもとしてかわいがっていますよ。いまではみんな、ひとつの幸せな家族なんです」**

みんなひとつの家族

あまりにカワイイから、つい仏心、ってやつよ

ライオンとレイヨウ

ナショナル・ジオグラフィック・チャンネルでやっているような野生動物のドキュメンタリー番組を見たことがありますか？　ライオンやトラが獲物を追いかけ、シマウマやレイヨウを捕える場面がよく出てきますね。

仲間に見捨てられ、喉に食いつかれた驚きの表情を浮かべて引き倒された動物が、あっという間に食べられてしまうことはみなさんもご存じでしょう。

ウガンダのクイーン・エリザベス国立公園で撮影をしていた野生動物専門の写真家、アドリ・デ・フィッセルも、2頭のメスライオンがそんな光景を繰り広げるところをレンズにとらえていました。

メスライオンたちは食事を終え、木の上に登ってひと休みしていました。

ふいに、小さな鳴き声が聞こえてきました。

木の上で耳をそばだてていたメスライオンの片方が、何事かと地面に下りてきました。

するとそこへ、茂みからレイヨウの子どもがふらふらと出てきたのです。親はきっと、いましがたメスライオンたちが食べてしまったレイヨウでしょう。

レイヨウの子どもは、下りてきたメスライオンのもとにまっすぐ向かい、そのお腹に鼻をこすりつけました。

レイヨウの角は中が空洞で、ずっと同じ角が生えたままになっています。シカの角が毎年生え替わるのとは対照的です。

あまりにカワイイから、つい仏心、ってやつよ

まるでお乳を探しているかのように。

「メスライオンはどうしていいかわからない様子でした」とデ・フィッセルは言います。

メスライオンとレイヨウの子どもは互いのにおいを嗅ぎ、相手の体を舐めました。

自分の子どもにするようなしぐさではありましたが、メスライオンはまだ戸惑っているようでした。

デ・フィッセルはすっかり感動して、何度もシャッターを切りました。

小一時間もそうしていたでしょうか、突然バイクのエンジン音が響きました。パークレンジャーが巡回に来たのです。

メスライオンはすぐにレイヨウの首のうしろをそっとくわえ、茂みのなかへ連れていきました。

レイヨウの子どもを守ってやるつもりだということは、くわえかたを見ればすぐわかりました。殺すつもりならその場で喉ぶえを食いちぎったでしょうから。

この話はそれだけで終わらないんですよ、とデ・フィッセルは言います。

「そのあとレイヨウの子どもが元気に飛び跳ねているところを見た、と言う観光客が大勢いたんです」*

子犬といるとあたし、目が優しくなるんです！

チンパンジーとイヌ

動物愛好家のグラハム・ジョーンズは、イギリスのダベントリー近郊の自宅に隣接した小さな野生動物園を開いています。

ジョーンズの理想は、人間に飼われているペットと、それより野生に近い動物の動物が仲良くいっしょに暮らす、いわばドリトル先生のお話の世界です。

野生動物とペットが友情をはぐくむ様子を見ると、ジョーンズはなんともいえない喜びを感じるのです。

理想を実現させたジョーンズでしたが、何頭かいるチンパンジーにだけは、悪さをしないかつねに目を光らせています。

退屈したチンパンジーが小動物を威嚇したり、腹立ちまぎれに地面にたたきつけたりするところを何度も目にしていたからです。

でもアンナというメスのチンパンジーだけは、ジョーンズも安心して見ていられました。

アンナは、自分より大きい相手に突っかかっていくことがなく、小さい動物も傷つけたりしません。母性本能がとても強いのです。

そんなアンナのお気に入りは、子イヌです。

ジョーンズの家ではイヌをたくさん飼っていますから、毎年何頭か子イヌが生ま

▶子犬といるとあたし、目が優しくなるんです！

チンパンジーはゴリラより人間に近いといわれています。チンパンジーのDNAの95から98パーセントは人間と同じなのです。

子犬といるとあたし、目が優しくなるんです！

れます。すると必ず、アンナがつきっきりで子イヌたちの世話をするのです。

アンナはお乳を飲んでいる子イヌたちを、いつも幸せそうに眺めています。

お腹がいっぱいになった子イヌを見つけると、そっと自分の腕のなかに抱きあげ、あやしてやるのです。

見知らぬ人間が子イヌたちをのぞきこもうものなら、アンナはまるでボディガードのように、子イヌの前に立ちふさがるのだといいます。

そんな様子をいつも見ている母イヌたちは、アンナがそばに来ても警戒することはありません。このチンパンジーだけは、子イヌを任せても安心だと思っているのでしょう。

それに、アンナが子イヌを見ていてくれるあいだは、母イヌたちもちょっとひと息つけますからね。

子犬といるとあたし、目が優しくなるんです！

トラだってライオンだって、育てるのは俺さ

オランウータンとライオン

動物園や自然保護区で、ライオンやトラの子どもの親代わりを人間から任されるのはたいてい、イヌです。

ところが、アメリカのサウスカロライナ州にあるマートルビーチ・サファリでは、食べ物や愛情を求める動物の子どもの親代わりはすべて、3才のオスのオランウータン、ハナマが務めています。

「ハナマはとても賢いので、親代わりには適任といえるでしょう」と、サファリの責任者、バガヴァン・アントル博士は言います。

このサファリパークでは、出産が近い動物は、動物学の専門家がチームを組んで、こと細かく観察しています。

そしていざ出産をむかえると、生まれた子どもが生存する確率を上げるために、スタッフが子どもを母親のもとから引き離し、人工飼育するのです。

ライオンのオスの双子、ススクーザとシムーも、生まれてすぐにハナマのもとへ連れてこられました。

「ハナマは2頭をすぐに抱きしめました。それ以来ずっとハナマは子どもたちを見守っています」と、アントル博士は言います。

「いっしょに走りまわったり転げまわったりしたあとは、優しく抱きあげてやるん

141

オランウータンはおもに木の上で生活します。これは主食がマンゴーやイチジクなどの果物だからです。

ですよ。どこへ行くにも2頭いっしょに抱えて歩いている姿を見ると、ハナマは本当に愛情深いお父さんだと思います」

けれど、スククーザとシムーの父親代わりはせいぜいあと数か月というところです。ライオンたちのほうが体が大きくなり、ハナマの手には負えなくなる日も近いでしょう。

「生後6か月から8か月で、おそらく2頭はハナマの体長を超えてしまうと思います。そこで親代わりはおしまいですね*」

ライオンの子たちが親離れしたら、ハナマは次の赤ちゃんがやってくるのを待つのです。

親のいない寂しさはあたしがいちばん知ってるもん

ヒヒとショウガラゴ

ケニアのナイロビ動物孤児院には、一年を通じていろいろな動物の子どもが運びこまれます。

アフリカのジャングルでは、親を殺されたり、親に捨てられて子どもだけになってしまうことはけっして珍しくはありません。

ですから小型の夜行性のサル、ショウガラゴの赤ちゃんが運びこまれたときも、スタッフは慣れた手つきでてきぱきと健康状態をチェックし、ミルクを与えました。

ガキイと名づけられたその赤ちゃんは生後3か月といったところでした。

まだひとりでは木に登れないガキイのために、スタッフは地面に巣を作ってやりました。

すると驚いたことに、同じように親を亡くして保護された生後7か月のメスのキイロヒヒが、木の上からガキイの巣まで下りてきて、自分の子どものようにかわいがり始めたのです。

「こんなことは初めてですよ。おそらく世界中探しても、赤ん坊が赤ん坊の世話をするなんて例はまず見られないと思います」と、動物孤児院で働くエドワード・カリウキは言います。

自分たちが珍しいケースであろうとなかろうと、キイロヒヒとガキイは気にもし

親のいない寂しさはあたしがいちばん知ってる もん

ていません。

ふたりはいつも寄りそって、ひとつのボウルからいっしょにミルクを飲んでいます。とはいえ、母親代わりのキイロヒヒも、まだ子どもなのでしっかり抱っこすることはできません。ガキイはすぐに滑り落ちそうになっては、あわててキイロヒヒの体にしがみつくのでした。*

ショウガラゴの体長はわずか6インチですが、うしろ脚の力がとても強いので、ジャンプすれば軽く20フィートは跳びます。

みんなひとつの家族

猛獣オオカミとしてはちょっと照れるぜ

ヤギとオオカミ

新疆(しんきょう)ウイグル自治区にある南苑子(ナンユエンツ)村で、近くの山に入った猟師が、死んだ母親の隣で丸くなっていたオオカミの赤ちゃんを見つけました。

かわいそうに思った猟師は、その赤ちゃんを村人のチェン・ミンの家に連れてきました。

チェンの家のヤギが最近子どもを産んだことを思い出したので、ヤギの乳を飲ませてやるというのです。

乳の量が足りず、オオカミに飲ませてやることはできませんでしたが、それでも母ヤギは自分の子ども同様にかわいがって世話をしました。

それから3年がたったいまでも、母ヤギとオオカミはぴたりと寄りそって暮らしています。

「食べるときも寝るときも、いまでもいっしょでね」と、チェンは言います。

「うちに遊びに来た人はみんな驚きますよ、だって食うものと食われるものが仲良くしているんですから」*

チェンはいつかオオカミを山に返したいと思っています。

ただ、出会ったその日からかたときも離れないふたりを見ているチェンには、きっとそんなことはできないでしょう。

146

猛獣オオカミとしてはちょっと照れるぜ

生まれたばかりのオオカミの子どもは目が見えません。初めて目を開けるのは生後2週間たってからです。

イクメンのハシリはサルでした！

タマリンモンキーと双子のマーモセット

同じ場所に暮らしていても、サルは種類ごとに別々に生活します。

「サル類が同じ種の子どもを育てる例は多く見られますが、違う種で子育てをしているのはうちの動物園だけでしょう」*と言うのは、イギリスにあるコルチェスター動物園のクライブ・バーウィック園長です。

コルチェスター動物園では、ゴールデンライオンタマリンモンキーのトムが、シルバーマーモセットという小型のサルの双子を育てているのです。

2011年3月、シルバーマーモセットの双子の赤ちゃんが生まれました。ほとんどが一度に1匹しか子どもを産まないサル類のなかでは珍しいことに、マーモセット類にはよく双子が生まれます。

サル類は全般に、お乳をやる母親が身の回りの世話などをおもに行います。母マーモセットも2匹を背中にしょって子育てしていましたが、双子はどんどん成長して、体も大きくなりました。

生後6週間を過ぎるころには、母マーモセットが2匹いっしょに背負うことは難しくなっていました。

それを見かねたのでしょうか、いつしかタマリンモンキーのトムが代わりにおぶってやるようになったのです。トムのほうが体は大きいので、軽々と2匹を背負って

148

野生のマーモセットは約30頭からなる群れをつくって行動をともにしますが、繁殖を行うのは1組のペアだけです。群れのなかでいちばん強いメスだけが、子どもを産むことができるのです。

イクメンのハシリはサルでした！

150

イクメンのハシリはサルでした！

いました。

マーモセットの父親はよく子どもを背負うのを母親と交代してやりますし、マーモセット類どうしで子育てを手伝うこともよくあります。でも違う種のサルの、しかもオスがベビーシッターを務めた例などこれまでにないでしょう。

マドンナやグウィネス・パルトロウのように、男性に子どもの世話を任せることが最近のトレンドになっていますが、そのはしりとなったのは、このマーモセットだったのかもしれません。

子牛に見間違えたわけじゃないんだけどね

ウシとヒツジ

2000年のクリスマスの日、ニュージーランドのペンカロウにある小さな牧場に、2頭の子ヒツジが生まれました。

しかし母親は、生まれた子ヒツジたちを見ようともしません。牧場を営むピジーニ夫妻もあの手この手をつくしましたが、母ヒツジが子育てしようとする気配は少しもありませんでした。はやく手を打たなくては、子ヒツジたちは死んでしまいます。でも牧場には、代わりに面倒をみられそうなヒツジはいません。困った夫妻は、牧場で飼っている2才半のジャージー牛、リトル・ブラウンに2匹を引き合わせてみました。

2匹を見た瞬間に、リトル・ブラウンは母親の目になりました。そしてすぐに世話を始めたのです。

子ヒツジたちが乳を欲しがればすぐに飲ませてやり、鼻先をすり寄せて甘えてくれば優しくこたえてやりました。子ヒツジたちもすっかりリトル・ブラウンになつき、寝ても覚めてもそのそばを離れませんでした。

年が明けた2001年には、ピジーニ夫妻の牧場で大きな牛と2頭の子ヒツジが親子のようにのんびり散歩する姿は、もう誰の目にもあたりまえの光景になっていました。

152

子牛に見間違えたわけじゃないんだけどね

人間の視界は半径170度ですが、ヒツジの視界は半径270度もあります。

みんなひとつの家族

動物保護と食肉の微妙な問題で有名になったよ

ブタとヒツジ

オーストラリアのビクトリア州に60エーカーの広大な敷地を持つエドガーズ・ミッション家畜動物保護センターには、ほかの保護施設とは明らかに違う点がひとつあります。

それは、食肉として家庭の食卓に並べられるような、家畜の保護を専門にしているところです。

きっかけは、創設者のパム・アハーンが出会った1頭のブタでした。

2003年、ビクトリア州に、ブタが主人公の映画『ベイブ』で農夫を演じた俳優のジェームズ・クロムウェルが訪れました。

ベジタリアンであるクロムウェルは、食肉用に飼育される家畜、特にブタがどんな劣悪な環境にあるかを世間に訴える活動の一環として、自分とブタがいっしょに映るポスターを撮影するために来たのです。

撮影に協力していたアハーンは、そのために近くの農場からブタを1頭、買い取っていました。

クロムウェルとの撮影が終わったら、エドガーと名づけたそのブタが、ずっと幸せに暮らせるような保護施設をさがすつもりでした。

けれど翌朝になると、どうしてもエドガーを手放す気にはなれませんでした。

154

動物保護と食肉の微妙な問題で有名になったよ

森の珍味トリュフを鼻先で探すよう訓練されるブタもいます。訓練次第では、爆弾や鉱脈を見つけられるようにもなるのです。

アハーンはエドガーのような家畜の保護に自分の人生をささげる決心をし、保護センターを設立したのです。

その後、アハーンはオーストラリア各地で、動物保護活動についての講演を行いました。舞台に上がるときにはいつも、エドガーにリードをつけて自分のそばに置きました。

エドガーは四本足の家畜保護大使として注目され、一躍有名になったのです。そのかいあって、アハーンの活動は順調に進みました。それから7年のうちに、保護センターには何百というヒツジやニワトリ、ヤギなどの家畜が保護されました。多いときで250頭までのぼったその動物たちを、エドガーは父親代わりとしてまとめました。

なかでもエドガーが特にかわいがったのは、生後1週間で保護センターにやってきた子ヒツジ、アーニーです。

エドガーはアーニーをひと目見た瞬間から、わが子のように大切に育てました。

エドガーはブタがただの食肉ではなく、親代わりを務めるくらい感情豊かな動物であることを証明したのです。

2010年にエドガーが亡くなったとき、そのニュースはオーストラリアから世界中に伝えられました。

鳥たちのニューファミリー

いのちを継いでいく、という話ですよ

メンドリとロットワイラー

イギリスのシュールズベリにある農場で、いずれどこかの家庭で夕食の一品にされてしまうはずだった1羽のメンドリが、イヌが産んだ子どもを育てて飼い主に恩を返したというお話があります。

農場の鶏小屋で生まれたごく普通のメンドリの運命が一変したのは、馬に足を踏まれたことがきっかけでした。

けがをしたせいでほかのニワトリより寒がっている様子を見かねた農場主は、そのメンドリを家のなかで世話してやることにし、メイベルという名前をつけました。動物に名前をつけるということは、その動物は食用ではなく家で飼うペットだということを意味します。農場主の優しさのおかげで、メイベルは命拾いをしたのです。

そのころ、一家が飼っていたロットワイラーのネトルは4匹の子イヌを産んだばかりでした。

ネトルはお乳をやったり舐めてやったりという母親らしいことがどうも苦手で、以前のようにひとり気ままに農場をうろついたり、珍しいにおいを嗅いでまわったりしたくてうずうずしていました。

ちょっと休憩とばかり、ネトルが子イヌたちを置いて外へ出て行ってしまったのを、メイベルはじっと見ていました。

> ロットワイラーは古くからある犬種で、その歴史は古代ローマ時代にまでさかのぼるといいます。人気が出たのはドイツで、ヒツジや牛を追うイヌとして使われました。

いのちがいのちを継いでいく、という話ですよ

■ いのちがいのちを継いでいく、という話ですよ

しばらく楽しんで戻ってきたネトルが見たのは、まるでひよこをあたためるかのように羽の下に子イヌたちを入れて座っている、メンドリの姿でした。

メイベルはただ温まりたくて子イヌのそばにもぐりこんだだけかもしれませんが、あまりに意外な光景にネトルも農場主一家も唖然としました。

その後、イヌの親子とメンドリはあたりまえのように共同生活を始めました。

「メイベルは子イヌたちを自分のひよこであるかのようにかわいがりましたし、はじめは戸惑っていたネトルも、嫌がりはしませんでしたね。むしろ手助け、いや羽助けというべきでしょうか、メイベルがいてくれて楽になった様子ですよ」と、農場主は言います。

「そのうちメイベルも卵を産むことでしょうが、このお返しにネトルがひよこの面倒を見てやるかどうかは怪しいですがね」

ニワトリがアヒルを産んだ⁉

メンドリとアヒル

今日は絶対ダイエットコークにするぞ、と思っていたのに、ついうっかりチョコシェイクを注文してしまうことってありますよね。そんなうっかりから素敵な結末が生まれることもあります。

イギリスのドーセットシャーにある農場で暮らしていた、ヒルダというメンドリのお話です。

2012年の春、ヒルダが5個の卵をあたため始めたことに気づいた農場主のフィリップ・パーマーは、黄色いひよこがよちよち歩く姿を楽しみにしていました。パーマーは子ども向けの体験農場を開いていたので、そこにひよこを仲間入りさせればきっと子どもたちが喜ぶだろうと思ったのです。

ところが、パーマーもヒルダもあっと驚くことが起こりました。生まれたのはなんと、アヒルのひなだったのです。農場ではニワトリとアヒルをいっしょに飼育していたので、メンドリのヒルダはうっかりアヒルの巣に座ってしまったのでしょう。

アヒルの卵のほうが明らかに大きいのですが、ヒルダは熱心にあたためて巣から離れなかったので、パーマーも気がつきませんでした。

思いがけずアヒルの母親になったヒルダでしたが、自分が産んだ子どもでないこ

鳥たちのニューファミリー

◤ ニワトリがアヒルを産んだ!?

アヒルの羽毛は生まれたときから水をはじくわけではありません。尻尾のつけねにある腺から脂が出ていて、成長するにつれてその脂が羽毛をコーティングしていくのです。

ニワトリがアヒルを産んだ!?

とはなんとも思っていなかったようです。

「ヒルダにとっては、アヒルであっても自分の子どもだったんです」とパーマーは言います。

アヒルには目を開けたときに見たものを親と思いこむ、すりこみという習性があるので、ひなたちもヒルダを母親だと思っていました。

「アヒルのひなたちはヒルダを一生懸命追いかけていました。わたしもはじめは驚きましたが、ちゃんと育てているならそれでいいと思うようになりました。ひなたちは母親がアヒルじゃないなんて思ってもいないようでしたし、ヒルダも自分のをよちよちついてくるのがニワトリじゃなくても、それがどうしたという顔でね」

メンドリのうしろを5羽のアヒルがバタバタとついて歩く光景は、農場の名物になりました。

「アヒルたちはヒルダのそばを離れませんでした。驚いたときはさっと『ママ』の羽の下に隠れていましたよ」*と、当時を思い出してパーマーは笑うのでした。

種の絶滅を救ったチャボのお手柄

チャボとハヤブサ

 イギリスのチェシャーに住むデイヴィッド・バンクルは鳥類の専門家です。20年以上前に自宅に作った鳥舎は4エーカーの広さがあり、たくさんのトリを飼育しています。1羽ごとの個性や気質を把握しているので、どのトリでもひと目で機嫌や体調の良し悪しがわかるといいます。
 だから、4才のハヤブサのメス、ショーラが巣作りを始めたとき、バンクルは急いで行動を起こしました。
 というのも、ショーラはそれまで何度も卵を産みっぱなしで放置していたからです。そのときもやはり、ろくにあたためもしないまま巣を離れてしまいました。
 ショーラはラガー種という、インド亜大陸に生息する珍しい種類のハヤブサです。イギリス国内にはわずか60羽しかおらず、世界でも合計で1万羽を切っているといわれる希少種です。
 つまり、ショーラが卵をかえさないのは、種の絶滅にもつながる危機なのでした。バンクルはすでにいろいろ準備をしていました。ショーラの卵と同じ時期にふ化しそうな卵がある巣を、鳥舎のなかで見つけておいたのです。
 ショーラの卵は、チャボのタフティが卵を産んだ巣に移されました。
「ハヤブサのひなを救うにはそれしか道はない、と思ったんです」バンクルはそう振

種の絶滅を救ったチャボのお手柄

ラガー種のハヤブサは、巣の周りをそれほど離れることなく生活します。

鳥たちのニューファミリー

種の絶滅を救ったチャボのお手柄

り返ります。

この方法は成功しました。タフティがあたためたハヤブサの卵からは、元気なオスのひなが生まれました。

とはいえ、ハヤブサのひなは生まれた早々から固形のえさを食べます。

ハヤブサのえさとして与えられていたのは、鶏の挽肉でした。

「チャボが鶏の挽肉をくわえてハヤブサのひなに食べさせるところなんて、さすがに見たくありませんでしたよ」*と、バンクルは言います。

ピングーと名づけられたハヤブサのひなは、バンクルが自宅に連れて帰ることになりました。チャボのもとで生後3か月まで育てられたピングーは、広げた羽の幅が3フィートにも達するほど成長し、立派に巣立っていったのでした。

うちの子は大食いでね

ヨシキリとカッコウ

野生動物の写真家、デイヴィッド・ティップリングが撮影した写真に、自分の体の3倍もあるカッコウのひなにえさを与えるヨシキリというトリの姿があります。2011年6月に、イギリスのイースト・ティルベリーという場所で撮影したものです。

カッコウは托卵と呼ばれる行動をします。母カッコウがほかのトリの巣に産みつけていった卵は、まるでカメレオンのように、巣のなかに先にあった卵によく似た色に変わって、ほかのトリにあたためてもらうのです。

ふ化したカッコウのひなは、目も開かないうちから、ほかのひなや卵を巣から押し出して落としたり、成長すると親鳥さえも追い出すといいます。

ティップリングが驚いたのは、撮影したカッコウのひなは親代わりのヨシキリとまったく争う様子がなかったことでした。その巣でふ化したのはカッコウのひな1羽だけだったようですが、大きさも羽根の色も自分たちとは明らかに違うカッコウのひなに、ヨシキリの両親はせっせとえさを運んでいたのです。

「ヨシキリは本当に自分たちの子どもだと思っていたのでしょう。近くあることにも、気づいていなかったと思います。体が自分の3倍の羽の下に入れてやろうとしていたくらいですから」

メスのカッコウは、一年のうちに
だいたい12個の卵を托卵します。

うちの子は大食いでね

> うちの子は大食いぞね

カッコウは生まれて18日目までに急速に体が大きくなり、羽根もひとりで飛べるくらい力強くなります。

ティップリングが撮った写真を見ると、大きな口を開けたカッコウのひなはヨシキリをまるごと飲みこんでしまいそうです。

ひなは相当成長していて、いまにも巣をひっくり返しそうでした。でもヨシキリの夫婦は、そんなことはお構いなしでひなを甘やかしていました。

「きっと、立派な家族をつくれたと誇りに思っていたのでしょう」*と、ティップリングは言います。

とはいえ、カッコウのひなはヨシキリの3倍はえさを食べますから、子育てに一生懸命のヨシキリたちも、さすがにえさ集めにはうんざりしていたかもしれません。

人間でいえばティーンエイジャーの男の子にごはんを食べさせるようなものなのでしょうね。

子どもが産めない猛禽がイラついた！

フクロウとアヒル

スコットランドのアバディーンシャーにある、ノースイースト鷹訓練センターには、ガンドルフという名前の15才のメスのフクロウがいます。

2004年の春、ガンドルフは手がつけられないほど攻撃的でした。その理由はおそらく、毎年きちんと巣を作り卵を産んで、何週間も辛抱してあたためているのに、1羽のひなも生まれないことでした。

センターを運営しているジョン・バリーは、何年もそんなつらい思いをしているガンドルフがかわいそうでなりませんでした。

そこで、少しでも母親の気分を味わわせてやろうと思ったバリーは、近隣の住民からもらったアヒルの卵をガンドルフにあたためさせてみることにしました。

とはいえ、卵がそもそも無精卵である可能性もありました。もしガンドルフが巣でその卵をあたため、自分のものでない卵は放置するものですし、殻を破って出てきたひながアヒルだと気づいたら、猛禽類であるフクロウはひなを喰い殺してしまうかもしれません。

ところが、そんな心配は杞憂でした。喜んで卵をあたためたため、無事にかえしたガンドルフは、生まれてきたアヒルのひなの母親代わりを務めました。

王立野鳥保護協会によると、そのような事例はごくまれだといいます。

「素晴らしい話ですね。フクロウがアヒルの親代わりをするなんて、野生ではまず起こらないでしょう*」

アヒルのひなたちを世話することで、ガンドルフは目に見えて穏やかになったといいます。

フクロウにはふたつの種がいます。メンフクロウと呼ばれる、ハート形の顔が特徴的な種と、真のフクロウと呼ばれる、丸い顔の種です。

あたしの子じゃないからって、どうなのよ?

クジャクとガチョウ

イギリスのストックブリッジという田舎町の農場でB&Bを営むキャロライン・ホールスは、友人からもらった2個のガチョウの卵を、農場で飼育しているクジャクのバレンタインの巣にそっと忍ばせました。

「店で買ったと聞いていましたし、ガチョウの卵は大きいですから、もしかしたら嫌がるかもしれないと思っていたんですが、意外にもバレンタインは、31日ものあいだ辛抱づよくあたためたんです」

そのかいあって、1羽だけ、黄色いひなが生まれました。

ひなにはグーシーという名前がつけられました。

「バレンタインはすっかりお母さんになりきっています。わたしがグーシーを抱きあげようとしたら、即座に腕をつつかれたくらいですから」

クジャクの子ではないとわかっていたかもしれませんが、バレンタインは毎日せっせとグーシーのために庭から虫を捕ってきました。

「ひなを連れて散歩しながら、えさになるものを教えてやっていますし、夜もちゃんと寝かしつけていますよ。そのうち、グーシーに飛び方を教えるかもしれませんね。大人になったグーシーがクジャクのように暮らすのか、それともガチョウのように生活するのか、いまから楽しみですよ」*

じつは、バレンタインは2年続けて、産んだ卵がかえらず、すっかり元気をなくしていたところでした。

「だからグーシーが生まれてくれたのは、バレンタインにとっていい気分転換になったと思います」と、ホールスは言っています。

> ガチョウは番犬の代わりになります。自分の縄張りに入ってきたものを威嚇する習性があるので、相手が何であろうと大きな声で鳴いたり、頭を地面すれすれまで下げてまっすぐ突き進んでいったりするのです。

気にしない気にしない、みんな鳥なんだもの

ニワトリとアヒル、カモ

アメリカのアイオワ州に住むドリーンとデイヴィッドのボウマン夫妻は長年農場を営んでいるので、種類の違う動物の親子ならいろいろ見てきました。

それでも、メンドリとアヒルがいっしょにカモのひなを育て、まるでひとつの家族のように暮らし始めたときには驚いたといいます。

事の起こりは、メンドリのヘンリエッタが卵を抱いている巣のすぐわきで、農場で飼われているカモが巣を作ったことでした。

ヘンリエッタは卵を産んでもかえったことがなく、そのときもひなは生まれませんでした。

ところが隣のカモの巣では、卵の殻を破る音が聞こえはじめた瞬間、母ガモがすっくと立ちあがり、巣を離れてしまったのです。

ヘンリエッタは、母ガモが出ていったと見るや、びくびくしながらも急いでカモのひなと卵を自分の巣へ移しました。

すべてのひなが生まれても、母ガモは戻ってきませんでした。ほっと安心したヘンリエッタは、子ガモたちを連れて散歩に出かけました。

その一部始終をじっと見ていたトリがいました。ヘンリエッタと同じく、自分の卵がかえらなかったアヒルのガーティです。

174

カモは卵からかえった翌日には
もう泳げます。

気にしない気にしない、みんな鳥なんだもの

▼ 気にしない気にしない、みんな鳥なんだもの

ガーティは何食わぬ顔で、散歩の列に合流しました。

「子ガモの姿を見た瞬間に、メンドリとアヒルは母親になったのです。いまではどこからどう見てもひとつの家族ですよ」と、農家のドリーンは言います。

その日からずっと、メンドリとアヒル、子ガモたちはいっしょに暮らしています。

「子ガモが何かに驚いてちょっと鳴き声をあげようものなら、ヘンリエッタもガーティもすぐに飛んできますね」*

2羽の母親代わりは、それぞれに仕事の分担を決めているようです。

ヘンリエッタはおもに子ガモたちの身の回りの世話とえさを受け持ち、ガーティは専属の水泳コーチ兼ライフガードを務めています。

子ガモたちの水泳指導中は休憩のはずのヘンリエッタも、池のそばで誰か溺れはしないかとおろおろしながら見守っていますけれどね。

注

はじめに

13
*　Alice Cooke, "Extraordinary Animal Friendships," Country Life, January 18, 2011.

14
*　"Gosling Who Thinks It's a Peacock," Rex Features, June 17, 2009.

14
**　Molly Badham, with Maureen Lawless, Chimps with Everything: The Story of Twycross Zoo (London: W. H. Allen, 1979), 112-13.

15
*　Molly Badham and Nathalie Evans, with Maureen Lawless, Molly's Zoo: Monkey Mischief at Twycross (London: Simon&Schuster UK, 2000), 200.

16
*　Susan Kauffmann, "Interspecies Friendships: When Cats Join the Pack," Modern Dog Magazine, Spring 2004.

16
**　同書

おかあさんになった犬

ちょっとそのほ乳びん貸して！　スプリンガー・スパニエルとヒツジ

20
*　"Meet the Ultimate Sheepdog! Springer Spaniel Jess Rounds Up Orphaned Lambs and Feeds Them from a Bottle Herself, "Daily Mail, September 18, 2012.

母性本能の正体なんて、詮索しないでくれる？　ゴールデン・レトリバーとウサギ

29
*　Tariq Tahir, "Cute Alert: Labrador Adopts Abandoned Baby Rabbits," Metro, May 24, 2011.

動物の面倒は動物にまかせておくのがいちばん　ジャーマン・シェパードとベンガルトラ

38
*　"Tiger," Reuters, April 2, 2001.

38
**　Holly Barnes, "Puppy Love: Vet Robert Zammit's Dog, Pepper, Administers TLC to One of the Orphaned Tiger Cubs Yesterday," Sun-Herald, January 4, 2001.

災害ボランティアのつもりだったんだけど　ジャーマン・シェパードとネコ

44 * Donna Carton, "A Kitten's Best Friend in Frankston," Frakston Standard Leader, February 23, 2009.

猟犬のあたしが獲物の母親にされちまった……　フォックスハウンドとキツネ

47 * David Hennessey, "Rescue Dog Nurses Baby Foxes," Greenwich Time, September 22, 2011.

あたし、赤ん坊に弱いのよ　グレイハウンドとシカ、キツネ、ウサギ

50 * Sian Powell, "Supermum! In the Past, Jasmine the Greyhound Has Fostered Birds, Rabbits and Fox Cubs… Her Latest Charge Is a Little Fawn Called Bramble," Coventry Evening Telegraph, July 16, 2008.

だって、体の柄がそっくりだったんだもん　ダルメシアンとヒツジ

54 * Mark Molloy, "Loving Dalmatian Adopts Abandoned 'Sheep in Dog's Clothing,'" Metro, August 15, 2012.

最後は命がけの子育てだったよ　ボーダーコリーとミニブタ

58 * "Mac the Maternal Border Collie Foster Dog Who Stepped into the Breach," Rex Features, April 25, 1997.

世界を救うのはきっと、母性なんですね　ラブラドールとカバ、トラ、ヤマアラシ

61 * "Motherly Love: Lisha the Labrador Plays Surrogate to…Tigers, Cheetahs, Porcupines, and Even a Pygmy Hippo," Daily Mail, February 2, 2009.

63 * "Motherly Love," Daily Mail, February 2, 2009.

63 * Marelize Potgieter, "Lisha Helps Raise Baby Tigers," Die Hoorn, February 12, 2009.

この子が大好き！

あたしを捨てた実の母よりどれだけいいか　グレートデンとシカ

66 * "They Say Every Dog Has It Doe," Sun, May 6, 2008.

69 * "Great Dane Makes a Deer Friend," Telegraph, May 6, 2008.

72 同情のつもりが愛情に変わったということかもね　ボクサー犬とブタ
* Paul Milligan, "A Piglet's Best Friend: Animal Forms Unbreakable Bond with Boxer Dog After Being Orphaned at One Day Old," Daily Mail, April 30, 2012.

72
** Rachael Misstear, "Unlikely Friendship of Norfolk Piggy and Welsh Puggy Is a YouTube Hit: Boxer Saved from Welsh Puppy Farm Hams It Up," Western Mail, December 24, 2011.

75 そうか、ぼくの前世は犬だったかも
* "A Badger's Best Friend," Daily Mail, April 6, 1998.

78 父性はそのまま母性にもなるってことさ　ボーダーコリーとハイエナ、トラ
* Suzanna Hills, "Puppy Love: But How Long Will It Last?" Daily Mail, May 14, 2012.

85 命にかかわるときは、ペットも野生もないって　ミックス犬とカンガルー
* "Best Mates, the Baby Kanbaroo, and the Wonder Dog That Saved It," Daily Mail, March 31, 2008.

86 三つ子だからって見殺しにはできないよ　ボクサー犬とヤギ
* "Paternal Dog Billy Takes on and Unusual Kid," Daily Mail, February 28, 2008.

90 愛してるからさ、離れたくないんだよ　ジャーマン・ショートヘアード・ポインターとコノハズク
* "Cherub the Baby Owl Is Reared with a Little Help from Pointer Kiera at the Devon Bird of Prey Centre in Newton Abbot, Devon, Britain," Rex USA, May 13, 2009.

98 おれの趣味は子育てだけど、こんどはアヒルかい？　イエロー・ラブラドールとアヒル
* "The Dog and the Duck: Labrador 'Adopts' Bird Whose Mother Was Killed By a Fox," Daily Mail, April 3, 2012.

101 犬猿の仲なんてウソ。とても犬身的なんです　グレートデンとチンパンジー
* Badham, Molly's Zoo, 201-2.

104 なぜひよこだってひよこだってわからんよ　おれにだってわからんよ　ケルピー犬とひよこ
* "Dopey Dog Love Is Chick Magnet," Rex Features, May 28, 2010.

猫たちの新しい家族

108 種類が違うとはいえ、別れはお互いつらいもの
* Chris Johnson, "Zara the Lion Cub and Arnie the House Cat Make a Purrfect Couple," Daily Mail, July 7, 2008.

111 だって、アタシはネコなんでしょ?　キツネとネコ
　ジョン・ドライスデールから著者へ直接のEメールによる　2012年12月7日

115 ふんわりふさふさの感触もネコっぽかったのかな　ウサギとネコ
* "Having Kittens: Rabbit Adopts New Feline Family," Daily Mail, November 19, 2007.

120 魔法のシャネル5番　ネコとリス
* "The Chanel Crossing: Perfume Spray Brings Together One Squirrel, Two Cats, and Ten Kittens," Daily Mail, September 14, 1996.

131 母親に捨てられたイヌたちがネコの家族になった　さび猫とロットワイラー
* "Cat Adopts Rottweiler Puppies," Mumbai Mirror, July 9, 2007.

131 **"Rottweiler Pup Whose Mum's a Moggy," Daily Mail, July 6, 2007.

136 あまりにカワイイから、つい仏心、ってやつよ　ライオンとレイヨウ
* Emma Reynolds, "Extraordinary Moment Wounded Lioness Shows Softer Side by Adopting Baby Antelope," Daily Mail, October 8, 2012.

みんなひとつの家族

143 トラだってライオンだって、育てるのは俺さ　オランウータンとライオン
* Paul Bentley, "I've Got My Hands Full Aping Mum: Orangutan Cradles Lion Cubs in Unlikely Babysitter Role," Daily Mail, September 3, 2010.

181

鳥たちのニューファミリー

145 親のいない寂しさはあたしがいちばん知ってるもん　ヒヒとショウガラゴ
* Sahra Abdi, "Clinging to the underbelly of a Baboon, Gakii, a Three-Month-Old Orphaned Bush Baby, Has Plumped for an Unlikely Surrogate Mother," Reuters, June 10, 2011.

146 猛獣オオカミとしてはちょっと照れるぜ　ヤギとオオカミ
* "Wolf and Goat Become Inseparable, Nanyuanzi Village, China," Rex USA, June 17, 2010.

148 イクメンのハシリはサルでした！　タマリンモンキーと双子のマーモセット
* "Tom the Monkey Childminder," Rex Feathres, May 17, 2011.

鳥たちのニューファミリー

160 いのちがいのちを継いでいく、という話ですよ　メンドリとロットワイラー
* Heidi Blake, "Hen That Thinks It's a Dog Takes Litter of Puppies Under Its Wing," Telegraph, March 4, 2010.

163 ニワトリがアヒルを産んだ!?　メンドリとアヒル
* Nick Enoch, "Waddle We Look Like When We Grow Up, Mum? Hilda the Hen Hatches Clutch of Duckling After Sitting on Wrong Nest," Daily Mail, April 4, 2012.

166 種の絶滅を救ったチャボのお手柄　チャボとハヤブサ
* Kate Hurry, "Who Are You Calling Chicken? Tufty the Hen's Adopted Offspring Will Turn Out to Be a Wild Thing," Daily Mail, April 24, 2001.

169 うちの子は大食いでね　ヨシキリとカッコウ
* "Cuckolded! The Little Red Warblers Fooled into Feeding Cuckoo Chick Three Times Their Size," Daily Mail, June 24, 2011.

171 子どもが産めない猛禽がイラついた！　フクロウとアヒル
* James Tait, "Owl Be There for You," Mirror(London), May 31, 2004.

182

あたしの子じゃないからって、どうなのよ。　クジャクとガチョウ

172＊ "Gosling Who Thinks It's a Peacock," Rex Features, June 17, 2009.

気にしない気にしない、みんな鳥なんだもの　ニワトリとアヒル、カモ

177＊ "Henrietta's Farmyard Family, Thayer, Iowa, America." Rex USA, November 2009.

写真引用元

ちょっとその哺乳びん貸して！　スプリンガー・スパニエルとヒツジ：Richard Austin/Rex USA

え？ あたしまたこんなに子どもを産んじゃったの？　ブルドッグとリス：John Drysdale

母性本能の正体なんて、詮索しないでくれる？　ゴールデン・レトリバーとウサギ
：Tina Case/Rex Features

ここにもひとつのクールジャパンがありました　秋田犬とライオン
：Mike Hollist/Daily Mail/Rex USA

いろんな子どもを育てたけど、この子は特別なのよ　ミックス犬とリャマ：John Drysdale

動物の面倒は動物にまかせておくのがいちばん　ジャーマン・シェパードとベンガルトラ
：Paul Lovelace/Rex USA

母親がイヌなら離乳食もドッグフード　ポインターとピューマ：John Drysdale

災害ボランティアのつもりだったんだけど　ジャーマン・シェパードとネコ：Newspix/Rex Features Ltd.

猟犬のあたしが獲物の母親にされちまった……　フォックスハウンドとキツネ
：Heren Neafsey, Hearst Connecticut Media Group

あたし、赤ん坊に弱いのよ　グレイハウンドとシカ、キツネ、ウサギ：Geoff Grewcock

だって、体の柄がそっくりだったんだもん　ダルメシアンとヒツジ：Media Mode Pty Ltd/Rex/Rex USA

ご注意！しがみつくクセは治りません　ミックス犬とショウガラゴ：John Drysdale

最後は命がけの子育てだったよ　ボーダーコリーとミニブタ：Mike Hollist/Daily Mail/Rex USA

世界を救うのはきっと、母性なんですね　ラブラドールとコビトカバ、トラ、ヤマアラシ：Courtesy of Cango Wildlife Ranch, Outshoorn, South Africa, and the Hall Family in loving memory of Lisha

あたしを捨てた実の母よりどれだけいいか　グレートデンとシカ：Richard Austin/Rex USA

同情のつもりが愛情に変わったということかもね　ボクサー犬とブタ：Maurice Gray/Caters News

そうか、ぼくの前世は犬だったかも　ミックス犬とアナグマ：Richard Austin/Rex USA

いやあ、子育てというのは大変なんですよ　チワワとマーモセット：John Drysdale

父性はそのまま母性にもなるってことさ　ボーダーコリーとハイエナ、トラ：Gallo Images/Rex/Rex USA

命にかかわるときは、ペットも野生もないって　ボクサー犬とカンガルー：Newspix/Rex USA

三つ子だからって見殺しにはできないよ　ジャーマン・ショートヘアード・ポインターとコノハズク：Richard Austin/Rex USA

愛してるからさ、離れたくないんだよ　大きな犬と小さなモルモットの愛情物語　エアデール・テリアとモルモット：Elaine Hu

残念ながら「いじめ」は動物の世界でもあるんだよ　イヌとサル：Top Photo Group/Rex USA

おれの趣味は子育てだけど、こんどはアヒルかい？　イエロー・ラブラドールとアヒル：SWNS

犬猿の仲なんてウソ。とても犬身的なんです　グレートデンとチンパンジー：Mike Hollist/Associated Newspapers/Rex USA

なぜひよこだって？おれにだってわからんよ　ケルピー犬とひよこ：Nicholas Welsh/Newspix/Rex USA

種類が違うとはいえ、別れはお互いつらいもの　ネコとライオン：SWNS

だって、アタシはネコなんでしょ？　キツネとネコ：John Drysdale

ふんわりふさふさの感触もネコっぽかったのかな　ウサギとネコ：Northscot Press Agency/Rex USA

やっぱり似た者どうしの心地よさってあるんだね　ネコとひよこ：Reuters/Ali Jarekji

魔法のシャネル5番　ネコとリス：Nils Jordensen/Rex USA

自分の子どもを亡くしたらネコだって淋しいのよ　ネコとカモ：Masatoshi Okauchi/Rex USA

豚のお乳を飲むと豚になってしまうというハナシ？　ブタとネコ：John Drysdale

母親に捨てられたイヌたちがネコの家族になった　さび猫とロットワイラー：Jerry Daws/Rex USA

あまりにカワイイから、つい仏心、ってやつよ　ライオンとレイヨウ：Adri de Visser/Caters News

子犬といるとあたし、目が優しくなるんです！　チンパンジーとイヌ：John Drysdale

トラだってライオンだって、育てるのは俺さ　オランウータンとライオン：Splash News

親のいない寂しさはあたしがいちばん知ってるもん　ヒヒとショウガラゴ：Reuters/Thomas Mukoya

猛獣オオカミとしてはちょっと照れるぜ　ヤギとオオカミ：Quirky China/Rex Features Ltd.

イクメンのハシリはサルでした！　タマリンモンキーと双子のマーモセット：Jeremy Durkin/Rex Features

子牛に見間違えたわけじゃないんだけどね　ウシとヒツジ：Stephen Barker/Rex USA

動物保護と食肉の微妙な問題で有名になったよ　ブタとヒツジ：Alex Coppel/Newspix/Rex USA

いのちがいのちを継いでいく、という話ですよ　メンドリとロットワイラー：Adam Harnett/Caters

ニワトリがアヒルを産んだ!?　メンドリとアヒル：Bournemouth News/Rex Features

種の絶滅を救ったチャボのお手柄　チャボとハヤブサ：Julian Hamilton/Rex USA

うちの子は大食いでね　ヨシキリとカッコウ：Solent News/Rex USA

子どもが産めない猛禽がイラついた！　フクロウとアヒル：Kenny Elrick/Rex USA

あたしの子じゃないからって、どうなのよ？　クジャクとガチョウ：Rex USA

気にしない気にしない、みんな鳥なんだもの　ニワトリとアヒル、カモ：Karine Aigner/Rex/Rex USA

ありがとう——♥

スーパーエージェント、スコット・メンデルに終わりなき感謝を。

セント・マーティンズ・プレスのインプリントであるトーマス・ダン・ブックスの編集者、ピーター・ジョセフにも感謝を。そして『ドッグス・オブ・ウォー』、『ドッグス・オブ・カレッジ』に続いてイヌと動物の作品を出版させてくれたトム・ダン、サリー・リチャードソン、マシュー・シェアにも同じく感謝を。所在のつかめないわたしの消息をつねに把握するという風変わりな才能を持つ、マーガレット・サザーランド・ブラウンとその後任メラニー・フライドには特別に大声で感謝を。また、こと動物の本となると素晴らしく有能な宣伝部、ジョアン・ヒギンスにも感謝を。

世界中のあちこちで、いつでもわたしにノートパソコンを使う場所を与えてくれる友人たちにも感謝。

ニューハンプシャーのシェリル・トロッタ、あなたと大量

のブリスケットやチョコレート、キャンティを交換するおかげでわたしの生活はなんとかもっています。サム・トロッタ、言うことを聞かない飼いイヌのコスモに「キッチンから出て行きなさい！」と言いながらしぶしぶ見逃してやっているあなたは、わたしに言わせれば永遠のいいお母さんです。ディーン・ホラッツとレスリー・カプート、いまこの瞬間は、急に飛び込んできて荷物を大爆発させてしまってごめんなさい。おわびにシーズのトフィーチョコキャンディをあげます。そしてもちろん、ボブとリーガン・プーチー・ディプレートにも。みんなありがとう。

チャールストンのジョン・ウィルソンとデイヴィッド・ポーター、毎週月曜の夜に励ましてくれてありがとう。おかげで次の月曜まで、コンピューターにかじりついての退屈な仕事に耐えることができました。それから、わたしがチャールストンに行ったときにはなぜかいつもそこにいる、マイケル・マレーにもお礼を。

最後に、いつも親切なアレックス・イシイにも、感謝しています……。

奇跡の動物家族
命をつなぐ
One Big Happy Family

2016年2月10日　初版第1刷発行

著　者　ライザ・ロガック
訳　者　宮垣明子
発行者　河村季里
発行所　株式会社K&Bパブリッシャーズ
　　　　〒101-0054　東京都千代田区神田錦町2-7 戸田ビル3F
　　　　電話03-3294-2771　FAX 03-3294-2772
　　　　E-Mail info@kb-p.co.jp
　　　　URL http://www.kb-p.co.jp

印刷・製本　株式会社 シナノ パブリッシング プレス

落丁・乱丁本は送料負担でお取り替えいたします。
本書の無断複写・複製・転載を禁じます。
ISBN978-4-902800-60-9　C0072
©2016 Lisa Rogak
　　　 Akiko Miyagaki

K&B PUBLISHERS

K&Bパブリッシャーズの本

地球新発見の旅シリーズ
絶景の旅 未知の大自然へ

K&Bパブリッシャーズ編集部/編

● 「地球新発見の旅」シリーズ第1弾。今すぐ出かけたくなる、本当に行ける世界の絶景43スポットを厳選して紹介。30年以上にわたって旅行ガイドブックを作り続けてきたK&Bパブリッシャーズが送る、旅の実現にいちばん近い本気の秘境トラベルガイド!

地球新発見の旅シリーズ
にっぽん 絶景の旅

K&Bパブリッシャーズ編集部/編

● 「地球新発見の旅」シリーズ第2弾。こんなに美しい風景が、にっぽんにもあったんだ! 日本各地67の絶景を迫力の見開き写真で、詳細地図とモデルプランなどきめ細やかな旅案内とともに紹介。週末1泊2日から行ける、お手軽&感動の絶景旅ガイド。

地球新発見の旅シリーズ
世界 動物の旅

K&Bパブリッシャーズ編集部/編

● 「地球新発見の旅」シリーズ第3弾。図鑑や動物園でしか見たことがなかった、あの動物たちの素顔を間近で見られる55スポットを紹介。100種類を超える愛嬌あふれる動物たちが登場。詳細な地図と現地での行動計画まで具体的に掲載し、アドバイスも豊富。

K&Bパブリッシャーズの本

地球新発見の旅シリーズ
ヨーロッパのいちばん美しい街

K&Bパブリッシャーズ編集部／編

● 「地球新発見の旅」シリーズ第4弾。おとぎ話に出てくるような家が並ぶ街、穏やかな時間が流れる田園、歴史の面影を今に残す城塞都市…。ロマンティック街道、プロヴァンス、コッツウォルズなど、いつか一度は行ってみたい憧れのヨーロッパの街を、11のテーマで厳選して紹介。

地球新発見の旅シリーズ
にっぽん 観光列車の旅

K&Bパブリッシャーズ編集部／編

●「地球新発見の旅」シリーズ第5弾。レストラン列車、トロッコ列車、SLなど、多彩な観光列車の魅力を豊富な写真で紹介。運行日時やチケット、沿線の観光情報などの実用情報のほか、鉄道会社からのメッセージ、乗車体験者の生の声も。巻頭に女優・室井滋さんのインタビュー収録。

地球新発見の旅シリーズ
にっぽん 寺社とお寺の旅

K&Bパブリッシャーズ編集部／編

●「地球新発見の旅」シリーズ第6弾。各地の寺社を、景色やロケーション、御利益などのテーマ別に紹介。参拝時に見逃せないポイントや、参拝がより楽しくなるマメ知識、寺社周辺の1日旅プランなど情報も充実。巻末の切り取って使える御朱印帳は初めての御朱印集めに最適。